EXPLORING IRAN

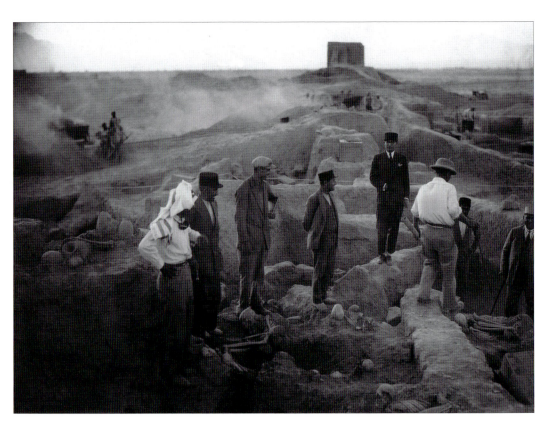

Frontispiece. Tepe Hissar excavations, during a visit by Iranian dignitaries. Schmidt stands on a baulk wearing his pith helmet; to his left is the Minister of Education; other individuals not identified. Fall 1932. Neg.#85206.

Ayşe Gürsan-Salzmann

EXPLORING IRAN

The Photography of
Erich F. Schmidt, 1930–1940

University of Pennsylvania Museum of Archaeology and Anthropology
Philadelphia, PA

Library of Congress Cataloging-in-Publication Data

Gürsan-Salzmann, Ayşe.

Exploring Iran : the photography of Erich F. Schmidt, 1930-1940 /

Ayşe Gürsan-Salzmann. -- 1st ed.

p. cm.

Includes bibliographical references and index.

ISBN 1-931707-96-0 (hardcover : alk. paper)

1. Photography in archaeology--Iran. 2. Iran--Antiquities. 3. Schmidt, Erich Friedrich,

1897-1964. I. Schmidt, Erich Friedrich, 1897-1964. II. Title.

CC79.P46G87 2007

935--dc22

2006100677

Ayşe Gürsan-Salzmann, a graduate of Robert College (Istanbul) and Ball State University, earned her M.A. and Ph.D. in Anthropology from the University of Pennsylvania. She has taught cultural anthropology and Near Eastern archaeology at Philadelphia's University of the Arts, Penn, and Bilkent University in Turkey. She has conducted archaeological and ethnographic field research in Turkey, Romania, and Uzbekistan. Since 1995 she has directed an ethnoarchaeological project at Gordion, Turkey, with emphasis on socioeconomic change, vernacular architecture, and material culture in the modern village of Yassihöyük. The recipient of many grants and awards, ranging from The American Philosophical Society to the Turkish Ministry of Culture and the U.S. National Endowment for the Humanities, she is currently working on the publication of the Bronze Age ceramic chronology of Tepe Hissar, excavated by Schmidt, under a White-Levy grant. She is a Research Associate of the University Museum.

All figures are from the University Museum Photo Archives, except the aerial photos which are reproduced from *Flights over the Ancient Cities of Iran* (Chicago, IL: Oriental Institute, 1940), courtesy of the Oriental Institute.

Printed in Canada on acid-free paper.

Contents

Preface

In June 1931 the University of Pennsylvania Museum of Archaeology and Anthropology launched its first Archaeological Expedition to Iran (then Persia), in conjunction with the Philadelphia Museum of Art (then Pennsylvania Museum of Art). Known as the Joint Archaeological Expedition to Persia, the project included excavation of the Bronze Age site of Tepe Hissar (4500–2000 BC) near the town of Damghan, in northeastern Iran, and the Sasanian Palace (3rd–7th century AD) constructed over the prehistoric settlement deposits. The Palace consisted of monumental buildings with exquisite stuccos from the pre-Islamic era (Schmidt 1933, 1937).

During the first season Tepe Hissar yielded a large inventory of splendid objects of gold and bronze ornaments, weaponry, jewelry of semiprecious stones, ceramics, elegant alabaster vessels. Reports by Pope about the Sasanian Palace excavations in the *Illustrated London News* (March 26, 1932) and the prehistoric finds (September 12, 1932, and January 28, 1933) generated much publicity in Europe and the United States. Public interest in turn helped to raise funds to ensure that the Damghan Project continued and it also enabled the University Museum to conduct research in Iran and in the Near East for decades to come.

The University Museum's director, Horace F. Jayne, had appointed Erich F. Schmidt, a young German archaeologist, to undertake the project. Schmidt had already conducted excavations in Arizona in 1925–26; he had been co-director of the Alisar excavations in central Turkey in 1927–29; and his affiliation with the American Museum of Natural History in New York had won him strong recommendations from such outstanding American archaeologists as Harvard's Alfred V. Kidder. Schmidt had trained in anthropology at Columbia University under Franz Boas, the father of American anthropology. Jayne was so impressed by Schmidt that in July 19, 1930, he wrote, Schmidt's "ambitions and abilities were too good to miss" (Hohmann and Kelley 1988).

The Damghan Project would lead Schmidt to later explorations at numerous sites and regions in Iran and provide him with a well-grounded career in Old World archaeology and a way of life as a wandering scholar which he reputedly enjoyed.

Schmidt's life story is full of dramatic events. Born in the southern province of Baden-Baden, Germany, in 1897, he was 10 years old when his father, a university professor and a Lutheran clergyman, died. On both sides of the family there were close German Army connections. After graduat-

ing from the *Kadettenkorps* in Karlsrühe and Berlin, Schmidt fought in World War I as an officer on the Eastern Front. Wounded and abandoned by the retreating German Army, he was eventually captured by the Russians and treated for his leg wounds that would leave him with a permanent limp. As a prisoner of war, he spent four years in a Siberian prison camp before escaping and making his way overland back to Germany. At the age of 24, he reinvented himself as a student of political science at Berlin's Friedrich Wilhelm University, where he studied from 1921 to 1923.

In December 1923 Schmidt came to the United States and studied at Columbia University from 1924 until he received his Ph.D in 1929. Schmidt's motives for moving to America and studying anthropology are not clear. According to one of his undated letters in the archives of the American Museum of Natural History (Wilcox 1988:16), his widowed mother and three siblings had died during or shortly after World War I. Perhaps this battle-scarred, adventurous young man believed the United States would provide him with a new way of life. He briefly explained his interest in anthropology in a letter of application to the American Museum of Natural History: "My training for ethnological and archaeological work is based practically on extensive travels all over the Old World inclusive of Russia and Siberia where I had to live in close connection with primitive peoples, Burraels, Kirgirs, Baschkirs." He went on to say that in Berlin he had also attended lectures on American archaeology which had inspired him to study archaeology and ethnology in the United States.

The American Museum of Natural History hired Schmidt, still a graduate student at Columbia, as a permanent staff member, a position that led him to his first fieldwork in Arizona, funded by the William B. and Gertrude H. Thompson family, who would remain one of his major benefactors until the end of his Iranian expeditions. One of Schmidt's mentors at the university was Professor Julius Goebel, who seems to have introduced him to the two people who played important roles in Schmidt's professional life: Fiske Kimball, then director of the Pennsylvania Museum of Art (later renamed the Philadelphia Museum of Art, co-sponsor of the Damghan Project), and Mrs. William B. Thompson (Majd 2003:94).

Largely through the perseverance of Schmidt and Jayne, the Damghan Project continued for two seasons, from June 1931 until December 1932, with the intervening winter months devoted to recording, drawing, and writing up the finds. The project was a great success, not only for its recovery of over 5,000 objects and a large number of burials, but also as one of the earliest systematic excavations undertaken in Iran. While it lacked the methodological precision and theory of contemporary archaeology, Schmidt's anthropological approach was revolutionary for its day. Tepe Hissar still provides the basis for interpreting the sequence of cultures in the region.

At the end of the second season half of the excavated artifacts had been selected and sent to the University Museum in Philadelphia. The other half was deposited in the Tehran Museum, in accordance with the division clause of the new Iranian Antiquities Law. The Philadelphia Museum

of Art acquired its share of the architectural stuccos only from the Sasanian Palace excavations. Schmidt and his team of White Russian and Polish photographers had taken nearly 2,600 black-and-white photographs, some of extraordinary quality, and pasted them in albums. Schmidt had deposited interim reports of the Damghan Project and most of the field documents in the Archives of the University Museum.

I became interested in these photographs while doing research in the University Museum Archives on the Bronze Age ceramics from Tepe Hissar. I came across Schmidt's 10-year correspondence with the University Museum's director and other scholars and diplomats. Schmidt's references to field photos led me to look through 15 oversized albums consisting of images of excavations and travels through the Near East. Photos of the Damghan Project are in the majority, but there are also images of Schmidt's travels to the Sumerian site of Fara (Iraq) undertaken on behalf of the University Museum and his later expeditions in Iran.

These photographs are remarkably clear, with a geographical spread covering vast territories of the Near East: from Istanbul to Baghdad to southern Mesopotamia, the Caspian Sea, and farther to the borderlands of south Central Asia. The images are revealing statements about Schmidt's curiosity, vision, and perseverance. They lead the viewer to accompany him and his team on their adventurous overland trips, capturing minute ethnographic and historical details.

Occasionally, Schmidt would ask his photographers to climb over rugged terrain to photograph a relief, or an inscription on a massive rock or catch the shadow of a gazelle on the distant hillock. They photographed people engaged in daily activities—except such important personages as a tribal leader who would be asked to pose formally in a dignified posture.

The archival documents are voluminous, providing correspondence, reports, and photographic images that inspired this book. They illuminate how and why the Damghan Project came about and the University Museum's logistics in launching a long-term expedition. It is remarkable that Schmidt's correspondence with the Museum director and others survived through the convoluted mail routes from the U.S. to Damghan to the U.S. Writing in his memoirs, Erskine L. White, the project's architect, mentions that "the mail went across the Atlantic by boat, across Europe to Berlin then to Moscow and from there to Baku on the Caspian Sea. From there it was just a short distance to Tehran by truck" (1960:31). Through Schmidt's correspondence, field notes and Road Diary we can envision the vibrant human experience embedded in his field research, well beyond his recording and interpreting the archaeological data. Some of the correspondence underlined the stark financial realities of expeditions, interesting behind-the-scenes information that site reports generally fail to include.

My challenge was first to create a visual narrative of the Damghan Project and its main participants who lived and worked more than 75 years ago. The research required closely reading and piecing together contextual information from letters, reports, and catalogues. The next task was to

select and assemble a balanced group of images from different categories. I frequently cited direct passages from Schmidt's letters to different directors of the sponsoring institutions and to colleagues, along with their replies to him. These letters were the best sources of unmediated information. Finally, out of several thousand images I selected 64 for printing in the book, with attention to their ethnographic and archaeological details, reproducibility, and aesthetic qualities; another group of dozens of images appears on the accompanying cd-rom.

To this day these photographs are some of the best sources of visual documentation of the cultural landscapes of Iran and Iraq, of the people and their monuments. They reveal a certain timelessness. While I was working on this book the war in Iraq was in progress, and in reading Schmidt's reports I was struck by their relevance to the present—the West's imperialist interests in the Middle East, a region where internal religious conflicts and tribal power struggles are intertwined and not well understood by the West. In some ways the documents bridged the recent past and the present, and they reminded me once again of their importance as historical sources.

A quarter of a century has passed since Iran closed its doors to research by Western scholars. I hope that in the coming decades the University Museum will continue to be actively involved in joint projects with Iranian colleagues, to build upon its scholarly research that was initiated by Schmidt in 1931 and continued by American archaeologists until 1979.

This book would not have come about without encouragement and editorial input from the director of University Museum Publications, Walda Metcalf, and support from the previous University Museum director, Dr. Jeremy A. Sabloff. Dr. Robert H. Dyson, Jr., was the guide and instigator of my interest in Bronze Age Iran and, specifically, in Tepe Hissar, and his support is significant. Alessandro Pezzati, the Museum's Senior Archivist, patiently and with good humor searched for and brought to my attention the many boxes of correspondence, the prints from the albums, and their negatives. To all four I extend my gratitude.

The translation of the Farsi was done by Nahit Bahrami, mother of Dr. Beebe Bahrami. My sincere thanks go to them both. My research assistant, Alison Miner, and my daughter, Han A. Salzmann, did the initial scans of the images. Francine Sarin did the final scans.

I am obliged to Erika Schmidt for contributing photos from her family album.

Special thanks go to my husband, Laurence D. Salzmann, who instilled in me an appreciation of well-conceived and professionally printed black-and-white photography for which he has won awards over the years.

Finally, the legacy of the University Museum is in part preserved in its valuable records and its publications of past projects which continue to benefit both the scholarly community and the public at large. I hope this book helps to demonstrate the vital importance of the University Museum as a major American research institution engaged in the Near East for over a century.

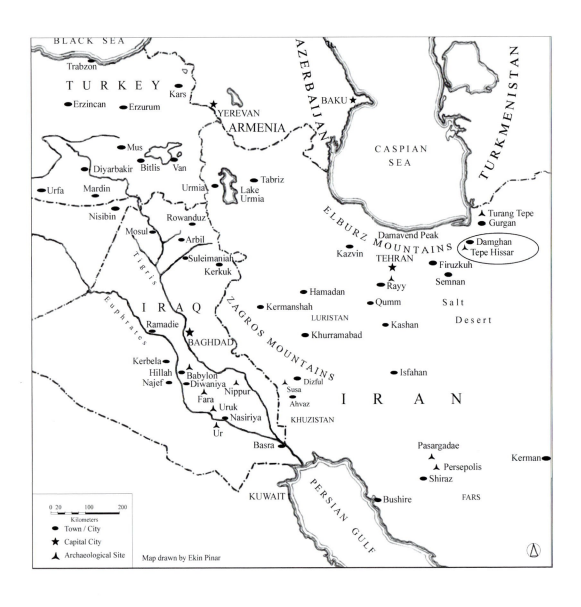

BLACK SEA

Trabzon

TURKEY

Erzincan Erzurum Kars

AZERBAIJAN

BAKU ★

★ YEREVAN
ARMENIA

CASPIAN
SEA

TURKMENISTAN

Mus

Diyarbakir Bitlis Van

Urfa Mardin Urmia Tabriz

Lake
Urmia

Nisibin Rowanduz

ELBURZ MOUNTAINS

Turang Tepe
Gurgan

Mosul

Arbil

Damavend Peak

Damghan
Tepe Hissar

Suleimaniah
Kerkuk

Kazvin

TEHRAN
★

Firuzkuh

Tigris

Hamadan

Rayy

Semnan

Euphrates

IRAQ

Kermanshah

LURISTAN

Qumm

Kashan

Salt

Desert

ZAGROS MOUNTAINS

Ramadie

★
BAGHDAD

Khurramabad

Kerbela

Hillah Babylon

Najef Diwaniya

Fara Nippur

Uruk Nasiriya

Ur

Susa

Dizful

Ahvaz

KHUZISTAN

Isfahan

IRAN

Basra

Pasargadae

▲

Persepolis

Kerman

KUWAIT

PERSIAN GULF

Bushire

Shiraz

FARS

0 20 100 200

Kilometers

● Town / City

★ Capital City

▲ Archaeological Site

Map drawn by Ekin Pinar

X

The University Museum's Damghan Project

For most of the first half of the 20th century Iran was still terra incognita archaeologically, except for the long-term monopoly on excavations held by the French. Under the French government's Délégation Scientifique Française en Perse, the Susa Expedition in Western Iran ran from 1897 to 1927, when Iran terminated France's singular role in the country. Other scientific explorations and travelers' accounts in nearby regions of Iraq, Turkey, and Turkmenistan had pointed to cultural connections with Iran, especially in the early prehistoric periods of the 5th millennium BC.

While the University Museum had already begun major excavations in Iraq, starting in 1888 at the site of Nippur, and continued on later at Ur, Tepe Gawra, and Beth Shan, the Damghan Project was to be the first American archaeological exploration in Iran. The Museum's Ur excavations, directed by C. Leonard Woolley, had yielded spectacular objects from the Sumerian Royal Cemetery and had established cultural connections with the prehistoric settlement at Susa.

To Horace Jayne, director of the University Museum from 1929 to 1941, the Damghan Project could provide another link in the chain of cultural connection between Mesopotamia and Iran. He also hoped that it would produce a wealth of objects to display in the University Museum as well as enhance the University Museum as a pioneer

American institution in Iran. The Project would come to fulfill both goals.

In early 1930 Jayne and Schmidt had established a gentlemen's agreement which Schmidt subsequently put in writing as a detailed memorandum on November 24, 1930, for Jayne's approval. It included Schmidt's job description, budget, staff, equipment, even countries to visit en route to Iran:

Position of Schmidt—It is understood that Schmidt will be the field director of this expedition, being responsible for its scientific, technical, and administrative phases. In addition it will be his duty to keep up the good relations between the Persian government and the home Institute [the American Institute for Persian Art and Archaeology, located in New York city], following the endeavors of Dr. Frederick Wulsin. The latter will stay with the expedition for about one month bringing about friendly relations between the expedition and the government officials. . . . As to Dr. Herzfeld, he will visit the site from time to time and act as scientific advisor. . . .

Budget—The expedition funds amount to $16,000. This sum includes the salaries of Dr. Wulsin, the architect-surveyor, and Schmidt, in addition to all expenses for equipment, material, travels, and labor wages. The fund is too small for a full staff. . . . It is understood that the expedition will work in the field until the entire amount is exhausted, and it shall stay in the field to resume the work as soon as additional funds will be available.

As in most cases, funding this expedition was also a critical matter. In the middle of the Great Depression financial support for the University Museum and most

educational and art institutions had been cut. On September 6, 1931, Fiske Kimball, director of the Philadelphia Museum of Art, co-sponsor of the expedition, described the seriousness of the financial situation: "The University Museum lost its entire appropriation from the City, and we at the Pennsylvania Museum lost $118,000 of our appropriation. We had to lay off practically half our whole force and close the two museum buildings on alternate days. You [Schmidt] can see that we have not been playing any favorites, and have not sacrificed the Persian Expedition to anything else."

Throughout the entire Damghan Project, the University Museum functioned on one-half of its regular income, reducing the administrative staff to four people, including the director, who, at times, was forced to sweep the hallways himself!

The University Museum began selling duplicates from some of its collections to replenish its operating budget. Despite its difficult financial circumstances the Museum had 15 excavations in progress, including the Damghan Project, from Alaska to Guatemala, the Mediterranean, and the Near East. In spite of all the financial barriers both Jayne and Kimball were determined to carry out the Damghan Project through private institutional support and individual patrons. While funding for expeditions today comes mainly from public agencies, in the early 1900s the funding pattern was largely from private sources.

Horace H. F. Jayne had become the director of the University Museum at the age of 31, and he wanted to initiate a project in a new region of the Near East. A Harvard-educated archaeologist and an expert in Oriental art, he was intellectually and socially well connected in Philadelphia. His father was an eminent scientist, founder of the Wistar Institute of Anatomy and Biology of the University of Pennsylvania. The

grandson of the Shakespearean scholar Horace How-
ard Furness, Jayne's maternal great-uncle was the re-
nowned Philadelphia architect Frank Furness, who
had designed the University of Pennsylania's Fine Arts
building which now houses its Fine Arts Library and
Arthur Ross Gallery.

Carrying out his desire to accomplish "stout deeds
on a lean budget" (Madeira 1964:42), Jayne appealed to
20 prominent Philadelphia families to contribute funds
to the project. Even his uncle was on the list. On Febru-
ary 28, 1930, he wrote, "My dear Uncle Judson: Can I be
forgiven if for once I become one of those objection-
able people who beg? It will not be a permanent role
and I hope I shan't have to do it again." In the end Jayne
succeeded in convincing 16 families each to contribute
$1,000 per year for three years.

Meanwhile, the University Museum had sought
additional funding. As a last resort, Schmidt offered to
contribute his salary, but that was rejected by both mu-
seum directors. Schmidt then turned to his earlier Ari-
zona benefactor, Mrs. William Boyce Thompson. Rather
than requesting financial aid directly from the Thomp-
son family, Schmidt wrote on March 5, 1930, to their
secretary, Mr. Cornelius Kelleher, discreetly appealing
for support:

> Cornelius, I don't like to do such a thing like
> applying for funds; but, after all, it is only indirectly
> for myself. Primarily it is for execution of scientific
> work. If I would be wealthy I would give my own
> funds. Please, do me the favor and submit the idea to
> our friend Mrs. Thompson. As I said, it would be just
> a matter of starting a campaign, showing that there
> is outside interest and a patron willing to furnish the
> initial funds. I think that Mrs. Thompson would be
> proud of the results.

The diplomatically worded letter worked. Mrs. Thompson became the Project's most loyal supporter, providing over $40,000 throughout its duration and contributing even more to Schmidt's subsequent projects in Iran. Schmidt's thriftiness and wise use of the Thompson resources played an important part in the Project's financial success.

IRAN IN THE 1930S

Schmidt's explorations in Iran and Mesopotamia coincided with ongoing European and American economic development and the administration of educational and cultural affairs. Since the turn of the century, under the auspices of the Anglo-Persian Oil Company, Britain had exploited the immense oil fields near the Persian Gulf. By 1925, under the reign of Reza Shah (father of the Shah deposed in 1979), the Westernization and modernization of Iran proceeded with great speed: the *Majlis* was modeled after the British Parliament, and German and American contractors were building a railroad system that extended from the Caspian Sea to the Persian Gulf. Western influence was visible in archaeological research as well, as the French had been digging at Susa since the mid–1800s. At the turn of the 19th century excavations were conducted principally under Jacques de Morgan and his assistant, Roland de Mecquenem, who later became the director at Susa.

The *Majlis* decided to end France's archaeological monopoly, with the mutual agreement in 1929 that the director of the Iranian Antiquities Department would be a French citizen, André Godard, who had trained as an architect and archaeologist. Godard's systematic and steadfast efforts resulted in the passage of the Iranian Antiquities Law in November 1930, prepared in cooperation with high-level Iranian bureaucrats and other foreign archae-

ologists. This new law signalled the University Museum to apply for an excavation permit.

The Museum's archival documents illustrate the complexity of communication networks among museum directors, diplomats, scholars, and the bureaucracy of Reza Shah's government. Schmidt's sensitivity about maintaining good relations with the political hierarchy, from the high-ranking officials in the central government to local tribal chiefs, clearly helped his long-term stay in Iran. He made a point of meeting with European consul-generals, British officers in Iraq, tribal leaders, various ministers of the Iranian court, and even the Shah himself. In his Fara report to Jayne, #1 dated March 1, 1931, Schmidt wrote:

> After about three hours we were in Diwaniyah [south of Baghdad] and drove directly to the Serai, [i.e. governmental building]. Major Ditchburn, [British political officer of the Liwa province] was informed about our coming. He was courteous and helpful, he advised us about the conditions in the district . . . [he] introduced us to the Mütesarrif (the governor of Liwa) and to the Kaimakam (next lower official) of the Fara county. He also informed us about the most important Sheiks we would have to deal with. The most powerful man of the Fara area is Sheik Shalon el Shehed of the Bderre tribe. . . . Our reason for mentioning all these names is obvious.

In a later note to Jayne, in October 1932, toward the end of the last season at Tepe Hissar, Schmidt clarified his political position vis-à-vis the Iranians and the staff of other Western archaeological projects:

> The policy of the expedition is rather simple and efficient. We play with wide open cards as to scientific and material results, and keep the inner

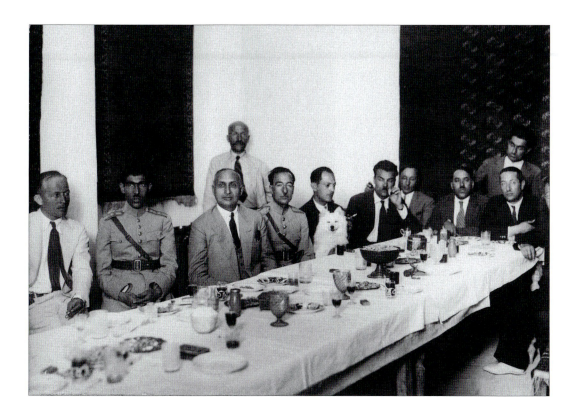

functioning of the expedition, including financial matters and private opinions to ourselves. In contrast to the secretiveness of some other enterprises round about, we show everything we found and people may look at everything. The exhibit in Tehran was to the best of the expedition [Figs.1,2]. It showed plainly the interest and the friendly feelings of the all-powerful HH. Teymourtache toward the enterpise [a forceful minister of court to whom Schmidt would later present an album of photographs from Tepe Hissar]. No difficulty can ever rise, as long as he is our friend. . . . We are on good terms with Prof. Godard, the Director of the Antiquity Service. The French diggers at Susa were very nice to us when we called on them this Spring. . . . Herzfeld's outfit is somewhat depressed, it seemed to us . . .[at Persepolis]. Darius' Harem has become their quite luxurious headquarters.

Figure 1. Dinner with Iranian bureaucrats and foreign guests at excavation house, Damghan. Schmidt, at far left, next to the Chief of Gendarmes; the Iranian Minister of education is flanked by two gendarmes. Note the guest with dog. Fall 1932. Neg.#85207.

Figure 2. Exhibit of finds from Rayy and Schmidt's other excavations in a private house that belonged to an Iranian aristocrat in a suburb of Tehran. The occasion coincided with the notable Persian poet Ferdousi's Millennium Celebration (pers. comm. A. Alizadeh). Fall 1936.

During 1935–39 Schmidt would become the director of Persepolis excavations.

Jayne's correspondence with several diplomats in Istanbul, Baghdad, and Teheran points to a wide circle of diplomatic connections that he cultivated in the Near East, including key officers in the American and British legations who were advising University Museum scholars about cultural issues and the political strategies of local governments. Such an international network proved to be very useful, especially for the secure and prompt delivery of letters and reports and for money transfers between Schmidt and Jayne.

Among the consultant-scholars involved in the project was Ernst E. Herzfeld, of the German Archaeological Service in Iran, who in 1925 had precisely located Tepe Hissar and had been a strong supporter of the Damghan Project. When Schmidt began his excavations at Tepe His-

sar, Herzfeld was excavating the monumental palace complex of king Darius and Xerxes at Persepolis, under the sponsorship of the Oriental Institute of the University of Chicago. Arthur U. Pope was an art historian whose long stays and connections in Iran would later help establish the American Institute for Persian Art and Archaeology (now known as the American Institute for Iranian Studies), with headquarters in New York City. Frederick Wulsin, an American archaeologist sent to Iran by Jayne in the early days of 1930, looked after the University Museum's archaeological interests. A few years later, Wulsin and his wife excavated another Bronze Age site at Tureng Tepe, culturally and chronologically related to Tepe Hissar. Both Herzfeld and Wulsin had acted as Godard's consultants in the preparation of the Iranian Antiquities Law. Last but not least, Mr. Mirzayantz, an Iranian deputy, rendered his invaluable services as a mediator among the Iranian bureaucrats, Schmidt, and the University Museum.

The Joint Archaeological Expedition to Persia had an extensive agenda. In addition to the excavation of the Tepe Hissar and the Sasanian Palace, Jayne had suggested testing the Damghan citadel, as the potential site of Hecatompylos, the Parthian capital, dated 129 BC–224 AD. But the citadel proved to be difficult to dig as it was next to the contemporary village and dated to the post-Islamic era, later than anticipated, so it was discontinued. Schmidt also agreed to undertake a short season of excavations at the Sumerian site of Fara, ancient Shuruppak, in the southern Mesopotamian desert, dated 3000–1900 BC, while waiting for the permit to excavate in Iran.

From Berlin to Basra to Fara

Schmidt's journey began in early January 1931 from Berlin to Istanbul on the Orient Express. In Istanbul he met with two of his American team members, Erskine

L. White, a student of architecture at the University of Pennsylania, and Derwood W. Lockard, the field assistant with whom he had worked in 1927–29 in Turkey. All three took the train from Istanbul across Turkey to the Syrian border town of Nisibin, continued overland to Kirkuk, then picked up the train to Baghdad, where they hired a local chauffeur, cook, and a foreman and purchased tents and some household equipment. They also bought a Ford truck in addition to the expedition car which Schmidt named "Ship of the Desert" or "camel." In Germany and the U.S. he had already bought four Zeiss cameras, a 16mm film camera, and essential dig equipment. He had even assembled a field library with books obtained from the two sponsoring museums and from bookshops in London and Paris before starting his trip from Berlin. Among his precious belongings were his portable typewriter, which would serve him well for a good part of his ten years in the field in Iran, a gramophone, and a box of classical music records. The team loaded everything onto their converted Ford truck bound for Baghdad, to Basra, and 150 miles farther south, to the site of Fara.

Schmidt's Fara Report #1, 1931, describes the journey from Baghdad to Basra:

At last on February 13, all our boxes and bales lay packed in the Hotel Claridge where we had stayed [Fig.3]. Much luggage was sent by train to the station of Diwaniyah, from which we intended to push on to Fara [about 50 km north of the ancient site of Ur in southern Mesopotamia]. . . . Lockard, White and Schmidt lay stretched out on top of the baggage and had a favorable view from this height for making the itinerary notes. . . . the dirt roads were good and dry. . . . Hillah [near Babylon] was our first aim, 139 km. from Baghdad. . . . Next morning we made a

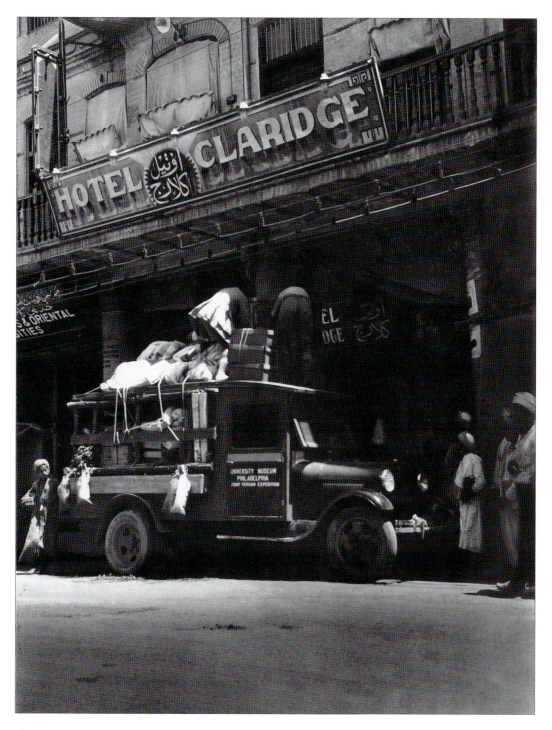

Figure 3. Excavation team departing Baghdad for the site of Fara. The loaded Ford "camel" which bears University Museum identification, is parked in front of the Claridge Hotel, which symbolized modernity. February 1931.

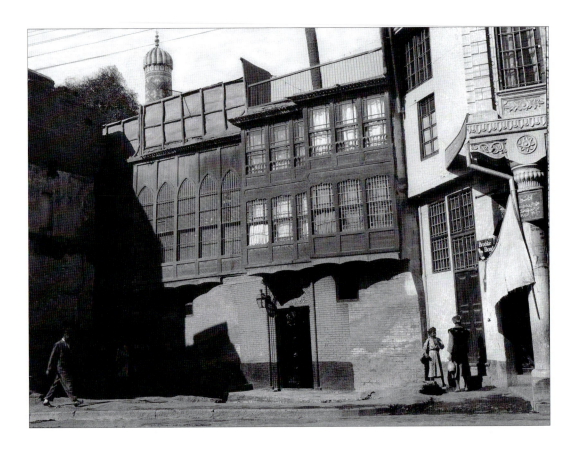

Figure 4. An Ottoman-style timber house in Baghdad. The style is known among the Baghdadis as "shanashil," which features a wooden screen across a closed-in gallery for women who could gaze outside without being seen by passersby (pers. comm. M. Moosa). February 1931.

pilgrimage to Babylon. . . . we saw the famous Ishtar gate with its beautiful animal decorations. . . . About noon we parted from the palm groves and drove on across the flat steppe, broken now and then by a cultivated patch. . . . the warm sun of the southern desert started to heal coughs and sciatica [Figs.4-8].

Using a portable bridge made of boards with iron ties and a pulley with ropes that they transported with them, Schmidt and company were prepared to brave the passage over broken bridges and ancient irrigation ditches. As much as they were prepared, they still had to rely on the good will and cooperation of the local sheiks and Emirs [Fig.9] for security against brigands and to have the numerous bridges repaired to cross the Euphrates River. It is not entirely clear if Schmidt knew when he enlisted the sheik's cooperation that he was being diplomatically helpful; according to

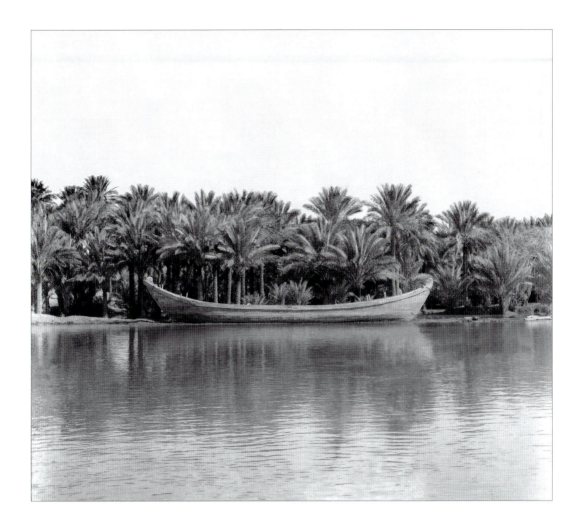

Middle Eastern tribal etiquette, a local sheik enhances his stature in the eyes of his tribesmen when he helps a needy foreigner. Schmidt continues his report:

> The bridge across a rather broad canal was impass-able and our own bridge boards were too short. The sheik Suweiyeh went on, on horseback, to reconnoiter the road but we had to return to Ibrah. Next morn-ing we arrived at the bridge, and got across! About 60 men of the Bderre tribe had labored all evening and night to fix it. . . . The road is marked by low piles of dirt at either side of a strip of desert Ancient ir-rigation canals had been filled or their banks had been cut . . . so we could cross.

Figure 5. Euphrates River scene at town of Hillah, famous for its thick stands of palms, near ancient Babylon. These boats were traditionally made of bundles of reeds or wood. Schmidt found an ancient clay model of the boat at Fara. February 1931.

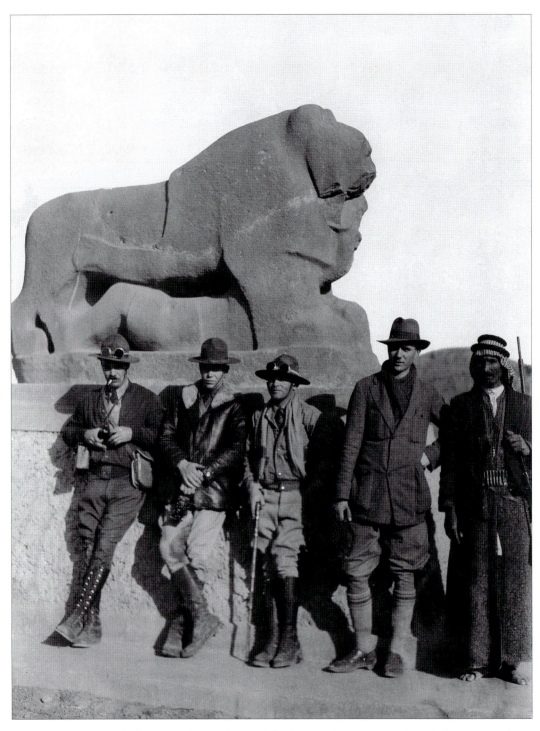

Figure 6. Visit to Babylon. Standing in front of the lion at the city gate, from left: Derwood W. Lockard, archaeological assistant; Erskine L. White, architectural assistant; Erich F. Schmidt; Kurt Leitner, surveyor/architect, and the Iraqi guide. February 1931.

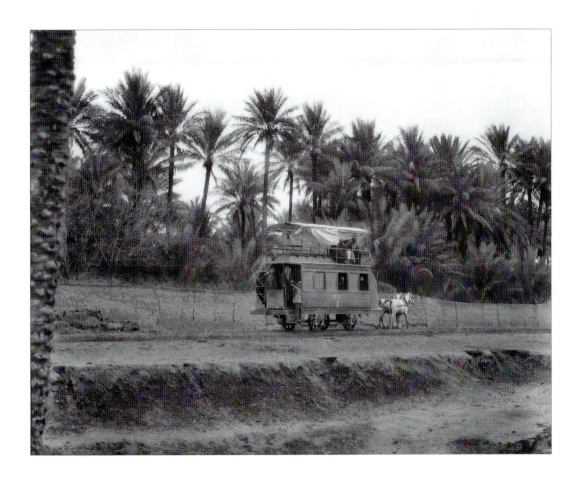

To return the favor to Sheik Suweiyeh, at a later date, Schmidt wrote a letter to Major Ditchburn, the British provincial officer, requesting that water be piped in for the tribesmen for their use. He later found out that it had been done.

At Fara

The Fara excavation season was three months of continuous, intense work from February to May 1931, picking up where the German-Babylonian Expedition, first under Robert Koldeway (1899) and later under Walter Andrae (1902–1903) had ended. After setting up a tent camp Schmidt proceeded to dig with 20 untrained tribesmen, two sheiks who were hired for political reasons as foremen, his architect, and his assistant archaeologist. He

Figure 7. "Arbana" or the "Kazimiyya Tramway" was the two-horse double-decker carriage that carried passengers across the palm groves from Baghdad to Kazimiyya. Built in the 1870s by the Ottoman governor Midhat Pasha, it marked the transition to modern transportation systems, with rails and wagons imported from England. January–February 1931.

Figure 8. Diwaniyah is a town about 200 km southeast of Baghdad, on the Dagharah branch of the Euphrates River. June 1931.

described the setup in the early days of camp life in his Fara Report [Fig.10]:

For about 28 years no Occidental had visited the site and our good "Camel" was the first automobile to reach it . . . we established our camp in the German Qal'a . . . tents and mats were spread over the best preserved rooms. In this manner we "rebuilt" a Museum and office room, a drafting room, a carpenter shop, a kitchen, a dining room . . . while we pitched tents as sleeping rooms. At once the digging of a well was started with a crew of about 20 men. . . . We struck ground water at 9 meters below the surface; but it was salty and could be used by the workers only to make bread. Thus our Ford had to continue carrying water over a distance of twenty-three kilometers from the region of Ebrah. . . . Three guards were employed who are proudly sporting their Turkish rifles and ammunition belts. The cook

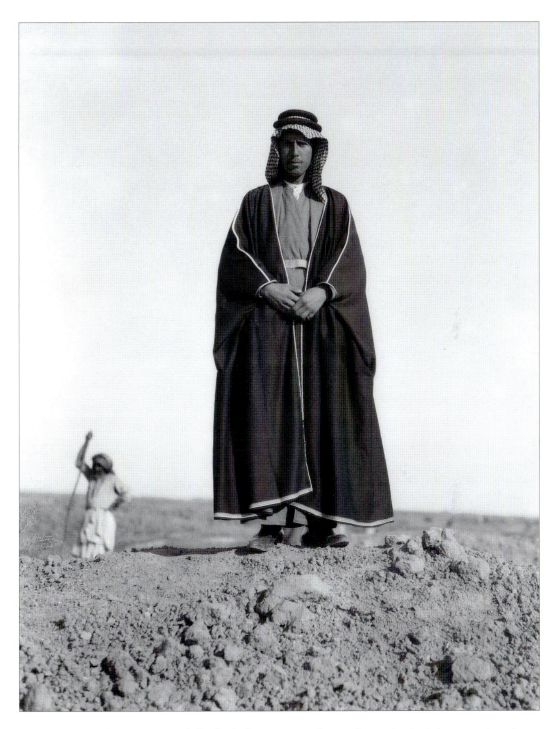

Figure 9. Abdul Ameer, son of Sheik Shalon, wearing his traditional "aba" (long coat) and headgear. Diwaniyah. February 1931.

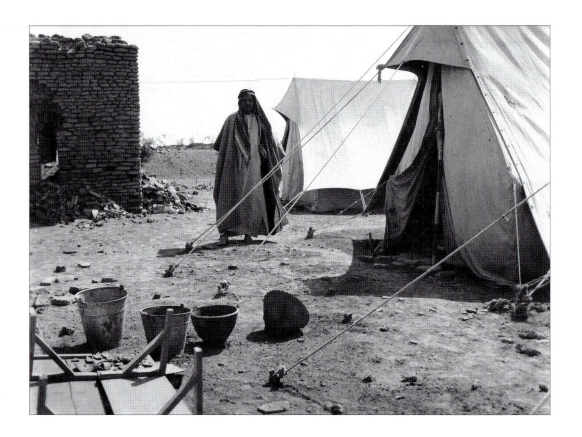

Figure 10. Fara expedition team camping on the edge of the site. February 1931.

bought fresh supplies, lambs, chickens and eggs to spare our stock of canned goods.

Schmidt's letters to Jayne from Fara expressed concern for the health and safety of his staff. He believed in preventive medicine, having ensured that all staff had received their inoculations against typhus and malaria. He had even managed to get a permit from the Iraqi Ministry of the Interior for himself and his staff to carry firearms in case of threats to the expedition from bandits, robbers, or opportunists. Fortunately, he never had to use his pistol. He described his anxieties about health at the camp in his May 1931 letter to Jayne: "In camp water was boiled, in order to prevent mainly a disagreeable infection of parasites connected in some way with snails, endemous [endemic] in southern Mesopotamia. Refuse places were disinfected with Carbolic acid. . . . White fell ill with a

rash. I sent him to Baghdad for a short time. . . . To date nobody shows, further, a sign of a Baghdad boil."

Life in the tent camp at Fara was very difficult on all team members. In his letter to Jayne from Fara, in March 1931, he described the quietly forbidding desert landscape and the treacherous sandstorms which hindered excavations:

> The vicious sand storms of the desert fill our tents and laboratories with thick layers of dust, and during squalls Arabs have to hang on to the "roofs" [temporary sheds] and tents to keep them from flying off. On March 1 we had a grandiose spectacle. A huge barrage of sand clouds came rolling across the plain [Fig.11]. It was so dense when it reached the camp that we had to breathe through wet towels to keep from choking. It was followed by a sandstorm that lasted five days and handicapped the digging and recording; but we worked during the whole time, except one half afternoon. . . . Personally I do not mind all that and take it with humor. . . . During the entire trip to Warka [the ancient site of Uruk dated to the 4th millennium BC] extensive tracts of hard sandy desert made fine roads for our truck, but there were scrubby patches which caught the dust-like sand, piling it up to low dunes.

Despite the debilitating desert sandstorms and a variety of indigenous rats which occasionally appeared at the tents in packs, Schmidt's good humor, as much as his dedication to his work, and the team's occasional trips to visit other sites in the region contributed to the success of the season at Fara. The test excavations at the site yielded over 70 unbaked cuneiform tablets and numerous seal impressions dated to the mid-3rd millennium BC. The University Museum's Assyriologist, Samuel N.

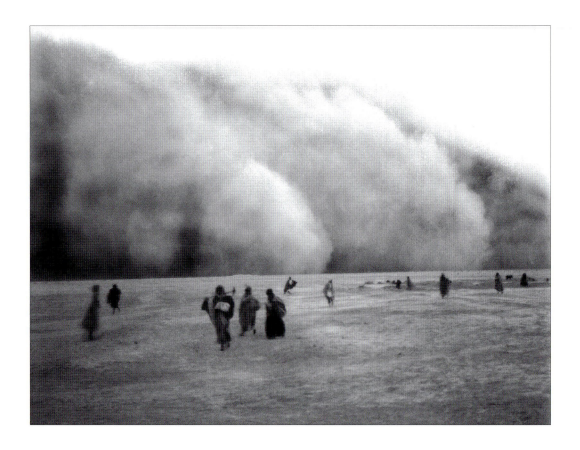

Figure 11. Sand storm at Fara. March 1931.

Kramer, subsequently deciphered the tablets. Although Schmidt strongly urged Jayne that they return to Fara for at least another season, Jayne was ambivalent about spending more time and funds at a site which had not proven to be a rich source of objects. While digging in Iran, in retrospect, Schmidt felt that Fara had been a great training field for him. In a letter dated September 30, 1932, he wrote to Jayne: "its teachings [work at Fara] would bear fruit later in Persia."

FROM FARA TO DAMGHAN

It took nearly a month to travel a distance of 2,000 km, with several stops along the way. Although gendarmes had warned the group not to travel at night for fear of being robbed by bandits, Schmidt frequently drove into the early hours of the morning after only a few intermittent hours

of sleep. In these overland reconnaissance trips Schmidt had an uncanny ability to absorb and remember many layers of landscapes. He would write about them in his reports, adding relevant photos. After the Fara excavation, driving north to Baghdad in the broiling heat of May, Schmidt and his staff passed through the sandy desert until they reached the palm groves of Shahraban. They then crossed east across the treacherous Zagros Mountains reaching Tehran by way of Luristan and Kermanshah [Fig.12].

Schmidt's notes about his trips are rich in detail, with insightful and colorful descriptions of landscapes, tells (man-made mounds), monuments, and even walled mudbrick villages which he especially noted while studying mudbrick architecture of Bronze Age Tepe Hissar. He described the built monuments of the past as an integral part of the natural environment which would have left an enduring mark on the imagination of people in antiquity [Fig.13]. For example, the awe-inspiring rock cliff of Behistun [Figs.14,15], rising 100 m above the plain, revealed reliefs and carved inscriptions to immortalize the ascent of King Darius to power. Schmidt also implied ritualistic relationships between archaeological and contemporary objects. In *Art and Archaeology* 33, 2 (1932), he wrote: "Once more we saw an *arwa'an*, the giant lizard of the desert which had served as pattern for certain figures on the Ishtar Gate of Babylon." He also suggested that such animal motifs as the gazelle, the leopard, or the ibex [wild goat] [Fig.16] that were frequently painted by ancient potters on early Hissar ceramics might have been inspired by the fauna that still lived in the high valleys nearby.

During their travels, the group stopped at roadside inns for lunch and lodgings, met the local people, and took many photographs. When some local villagers of a roadhouse inn invited the group for lunch, a Middle Eastern gesture shown to travelers from other lands, Schmidt graciously accepted their hospitality [Fig.17]:

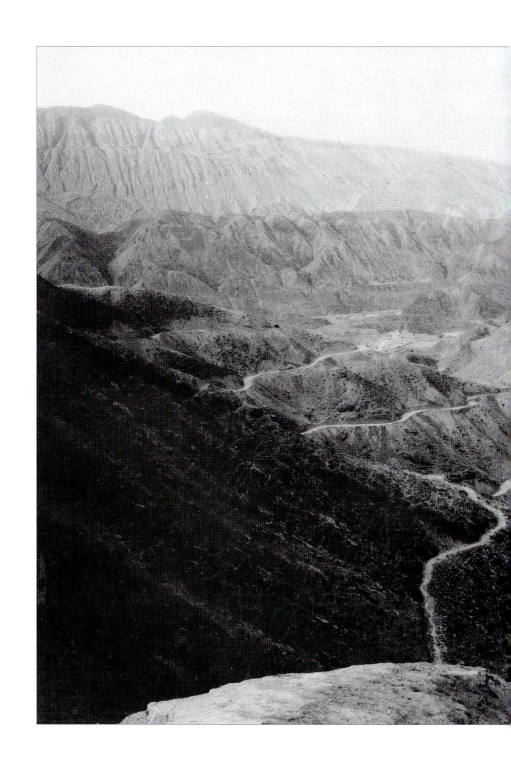

Figure 12. A serpentine highway through the Delikli Pass, across the Zagros Mountains, near the southern city of Shiraz. March 1933. Neg.#83433.

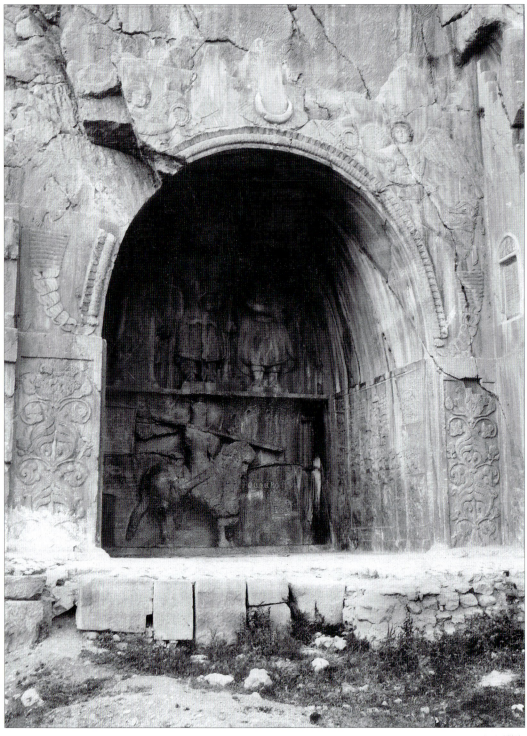

Figure 13. Sasanian Rock relief (Taq-i Bustan) depicting a triumphant King Khosrow II on his horse, 4th century AD, north of Kermanshah in western Iran. Spring 1931.

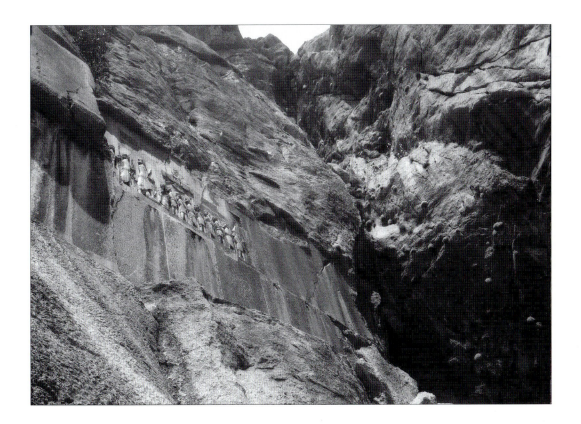

At last, one hundred and ninety kilometers from Kermanshah we reached [the] foot [of the mountain] at the town of Assadabad. . . . A little roadhouse on the summit gave us a welcome excuse for stopping. There were eggs, tea, cucumbers and bread, for us, and water for the steaming engine. . . . The plain of Kermanshah is covered with wheat fields and grasslands, but the town itself is enclosed by fields of poppies. There were groups of people going from seedpod to seedpod, incising them to make the precious opium juice to flow. The town itself is doubtless built on earlier sites though there is no pronounced tell formation. Small hillocks of culture deposit are near Tak–i Bustan.

The trip between Kermanshah, a border town between Iraq and Iran, to Tehran and farther east to Damghan took 12 days of constant traveling, a distance of nearly 530

Figure 14. The rock at Behistun, near Kermanshah. The relief carved in 520 BC depicts Darius I celebrating his conquest over the nine rebel kings in order to preserve the Persian Empire. The inscription was carved in parallel columns, repeating the same text in three languages—Elamite, Babylonian, and Old Persian—and it records his genealogy and victorious deeds. June 1931. Neg. #80871-77.

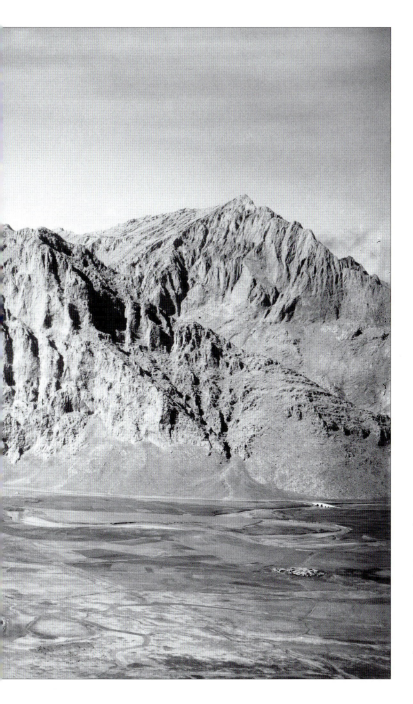

Figure 15. The Rock of Behistun, as seen from Schmidt's aerial shot (taken from an altitude of 520 m), is a precipitious limestone outcrop above the village of Bisitun. The Royal Road runs along the base of the mountain, extending for about 2,500 km (1,600 miles), from southern Iran to western Turkey. June 1934.

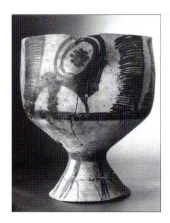

Figure 16. Pottery bowl, brown on buff background; ibex decoration in three panels separated by tree branches, dated c. 4100 BC. November 15, 1932 (Schmidt 1937:47). Neg.#85204.

miles (850 km). Schmidt continued to describe in detail the location of many tells, standing monuments such as Islamic fortresses, graveyards, even the shape of gravestones.

At the end of a long segment of the trip Schmidt splurged on staying overnight at the Hotel de France in Hamadan (ancient Ecbatana). One of the high points of the trip was visiting Hamadan and searching for the ancient Medean capital. Another particularly beneficial visit was to the large Islamic city of Rayy, with its crumbled fortifications rising above the plain, across from an Islamic sanctuary [Fig.18]. In 1934, two years after the end of the Tepe Hissar excavations, Schmidt would return to dig the sites of Rayy and Cheshmeh Ali, the nearby prehistoric mound.

The seemingly rigid Iranian bureaucracy actually proved flexible to Schmidt as he learned more about what he referred as "oriental" culture. Using all his connections—local, personal, and institutional—he proceeded to Damghan, arriving in the early morning at half past four. The group then drove directly to the Custom House as they had been instructed. Due to the efforts of friends in Teheran they had acquired the necessary permits, so the formalities proceeded seamlessly.

Figure 17. Luristan hospitality at an open roadside "chaikhana" (teahouse), around the Rumishgan Valley. On left: Lur shepherds with traditional conical caps; right: men with official "Pahlavi" hats.

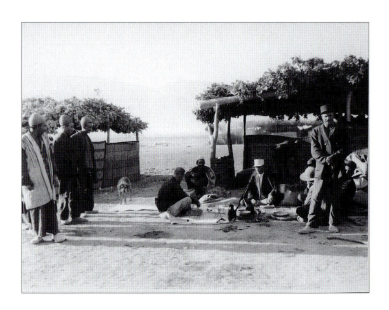

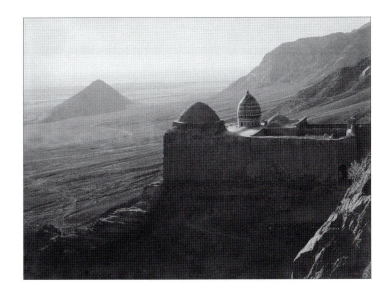

Figure 18. Seljuk (Islamic) sanctuary above the plain of Rayy.

Schmidt's travel log, as reported in his *Art and Archaeology* article, is full of dates for arrivals at and departures from various places, times spent, and descriptions of dramatic moments of arrival which elated him on reaching a new place, as from Kazvin to Teheran:

> At four o'clock, when it was just getting light, we stopped at an idyllic roadhouse in a grove of huge trees from whose branches hundreds of crows saluted the morning with their unmelodious voices, while we consumed quantities of tea. . . . As we drove on we soon had the first view of the majestic Mound Demavend [Fig.19, part of the Elburz Mountain range], its snowy peak looking like a brilliant cloud cap. . . . We arrived at the gates of Teheran and grimy as we were, drove straight to the American Legation to pay our respects and gather up our mail.

On the early morning of June 17, 1931, some 220 miles (350 km) east of Tehran, the expedition crew had reached their final destination, the town of Damghan [Figs.20,21].

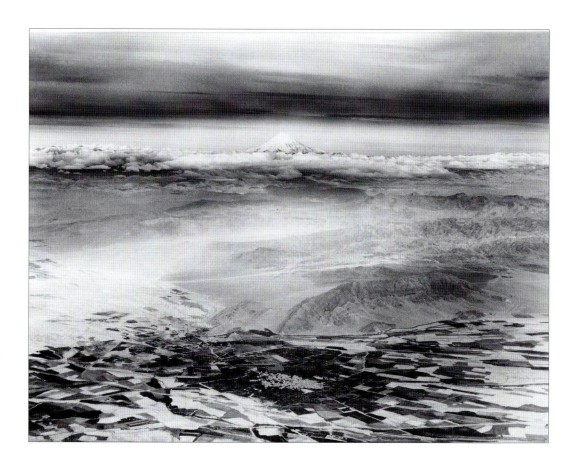

Figure 19. Aerial view of the giant, snow-capped cone of Mt. Demavend that towers over the city of Teheran (18,600 ft).

It had been a very long journey of some 950 miles (1,500 km) from Fara to Damghan.

Schmidt's reports to Jayne, some written during the long, overland travels and posted hastily along with a telegram to the University Museum, formed the basis of his popular articles and reports to the Museum's Board of Overseers for the project's evaluation and continued funding. Throughout the duration of the project, his letters reflected anxiety about continued funding. As he wrote explicitly to Jayne, in June 1932, at the beginning of the second season: "Today I will send you the following deferred cable: 'Cable funds Baghdad uncovering palatial prehistoric building splendid alabasters copper dagger silver grip many gold silver agate ornaments great stuff. . . . This cable means that I am out of funds. According to our mutual plans I had figured with transfer of Dollars five

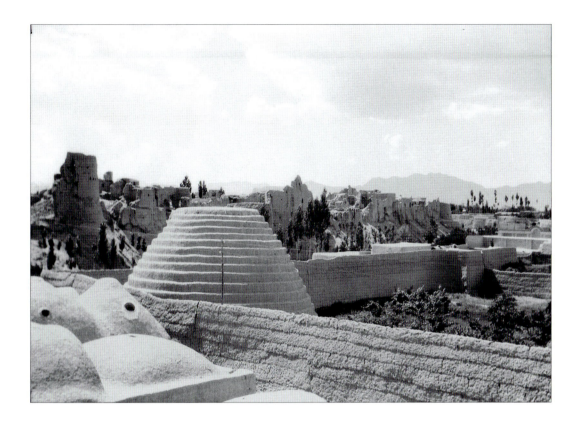

thousand from Philadelphia about June first. To-day I had to lay off a hundred men, and the rest will follow if I don't get the money very quick."

The urgency of the message is clear; Jayne's response to it was favorable and prompt, as he must have been impressed with the successes of the expedition.

Figure 20. East wall of the Damghan fortress on the citadel; pyramid-shaped icehouse in foreground. June 1931. Neg. #80958.

EXCAVATING TEPE HISSAR AND THE SASANIAN PALACE

Compared to the exhausting camp living at Fara, the conditions at Damghan were luxurious. The crew moved into the expedition house which had 23 rooms, a center court with a swimming pool, and a garden. The rent was $9.00 per month. It had been the residence of the chief of the gendarmerie [Fig.22]. The Schmidt household

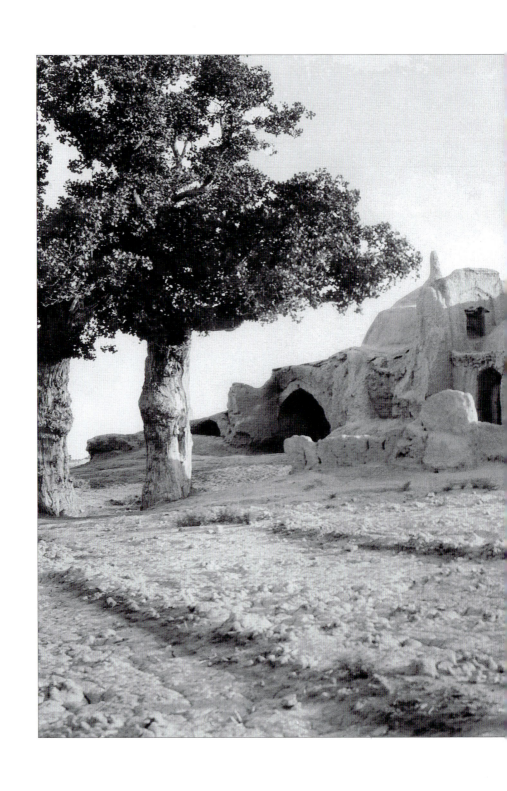

Figure 21. An Islamic shrine near Damghan, built in the 7th century AD with inscriptions for Imamzade Abbasabad, descendants of the Prophet Muhammad. Like the Damghan Citadel, this tomb consists of a series of mudbrick structures that have withstood the elements over time. July 1931. Neg.#82646.

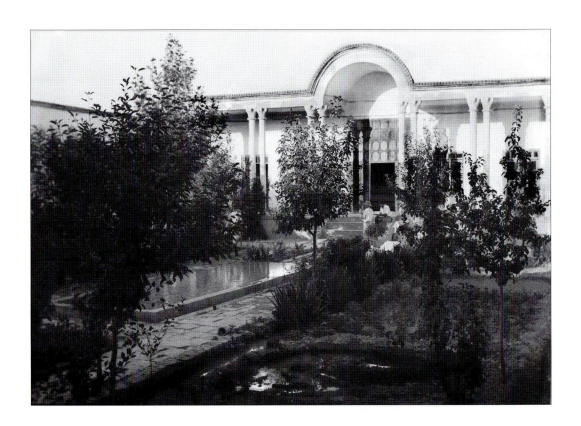

Figure 22. Damghan Project excavation house. July 1931. Neg.#82581.

consisted of seven staff members in addition to a head foreman, a cook, a chauffeur, and several local houseboys as servants. They were an international group: Derwood W. Lockard, assistant archaeologist, and Erskine L. White, assistant architect, both were Americans; Kurt Leitner, the surveyor, was Austrian; Stanislaw Niedzwiecki, the photographer and artist, was a former Czarist officer from Poland; Boris Dubensky, another photographer, was a White Russian; and Ivan Gerasimoff, an artist who did all the object drawings and exquisite renditions of some of the objects in watercolor, was also a White Russian. Schmidt considered the work of both Dubensky and Gerasimoff indispensable. They were his most loyal and industrious workers, and he instructed them to explore Iran pictorially "with open eyes for archaeological remains."

Schmidt also had various pets: two dogs (Hissar and Wolf), two gazelles (one named Giza), a hawk (Hawky),

a dove (Josephine), a bluebird and a hedgehog, and an owl (Pidar Sukdeh) that became his constant companion around the house [Figs.23,24]. Wolf appears to have been another Schmidt favorite which he took to the site, on his reconnaisance trips, and to Tehran at the end of each season. Sensing Schmidt's love of animals the locals would bring him pets for which they would be paid some miniscule sum. In some of his personal letters Schmidt refers to his pets as his "dear friends" that made life less lonely at the camp.

The work routine was orderly and punctual, 12– to 15-hour work days, divided between the mound and the house. Tepe Hissar, "Castle Hill," and the Damghan Citadel excavations combined lasted two long seasons totaling 14 months. During that period the team also did several test digs at nearby sites. At the end of the first season the team spent the winter months in Tehran; the following winter they stayed at the excavation house in Damghan to finish recording, drawing plans and objects, settling accounts, and writing reports.

Schmidt was very clear about the dual nature of his mission: conducting systematic, "scientific" excavations, and retrieving opulent objects for the sponsoring museums and benevolent donors. Concerning the latter, on December 29, 1930, he wrote to Jayne from Berlin at the outset of his voyage to the East: "I want to mention that Mrs. Thompson would like to have a small collection of minor objects, such as a few pots, metal, bone and stone specimens. This would only be fair, and, at the same time, her collection would doubtless have the character of a loan, since I am certain that they will be returned to the Museum after her disease [decease]." The Museum did, in fact, receive part of Mrs. Thompson's collection from Pennsylvania's Senator Hugh D. Scott, who acquired it from her heirs.

Tepe Hissar is the largest excavated Bronze Age site in northern Iran to date. It is located at the southeastern

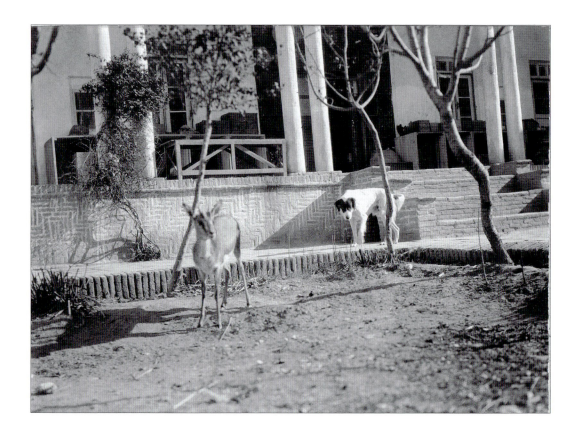

Figure 23. "Hissar" or "Wolf" the dog and "Giza" the gazelle in the garden of the excavation house.

tip of the Caspian Sea, tucked into a fertile valley, on the edge of the salt desert (see map). It consists of six hillocks representing different settlements, connected by flat areas. Albert H. Schindler (1887) drew attention to it in the 1870s when some painted pottery was discovered there. In 1925 the German archaeologist Ernst Herzfeld visited Tepe Hissar and catalogued the sherds found on the surface. However, it would be some 50 years later, in 1976, for Robert H. Dyson, Jr., of the University Museum and Maurizio Tosi of the University of Turin to begin the first systematic re-excavations at the site.

When Schmidt surveyed the mound in 1931 it was densely covered with potsherds which gave him a preview of the pottery types he would find there [Fig.25]. He dug at Tepe Hissar at a feverish pace, at times employing a record number of 200–300 workmen, sometimes fewer when funds were short. Using a railroad and wagon sys-

tem, the most efficient technique employed in the 1930s, the excavated earth was carried to the edge of the mound, forming another mound called a "dump."

The Sasanian Palace had a colonnaded hall; it was lavishly ornamented with wall paintings, plaques, and an extraordinarily rich store of decorative stucco ornaments which were sent to the Philadelphia Museum of Art [Figs.26-28].

During two seasons of excavations at Tepe Hissar an overwhelming number of 1,637 burials with splendid mortuary objects of many categories were excavated. They rivaled the Royal Tombs of Ur in richness of materials and craftsmanship. Each skeleton was carefully recorded, its position and direction of the skull sketched and photographed. His training under Franz Boas at Columbia University had taught Schmidt to measure skulls for possible evidence of racial identification. He then sent them to Philadelphia for further analysis. (Some of the human skeletal material is kept at the University Museum.) Schmidt assigned titles to certain graves such as "Dancer's grave," "Warrior's grave," and "Young Child's grave," based on the position of limbs at interment and the types of objects found with the deceased. He described the "Dancer's grave" [Fig.29] in his letter to Jayne, June 16, 1932: "Just now I am preserving the mortuary equipment of a woman whose hands were in an elegant dancing pose.... silver rings at her fingers, tinkling copper rings at her ears.... and the most exquisite collier [necklace] we found to date. It is composed of little effigies of lapis lazuli, turquoise and silver with silver tubes and long lapis beads. The dancer was in the periphery of the burned building."

In about 2000 BC part of the settlement had suffered an extensive fire, preserving hundreds of objects under its collapsed floors and walls, as well as in the graves. Among the mortuary gifts were bronze daggers and figurines, elegant alabaster vases, stamp and cylinder

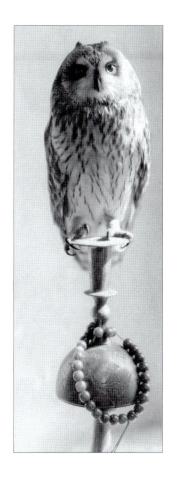

Figure 24. Schmidt's owl on a candlestick from Isfahan. Fall 1932. Neg.#85413.

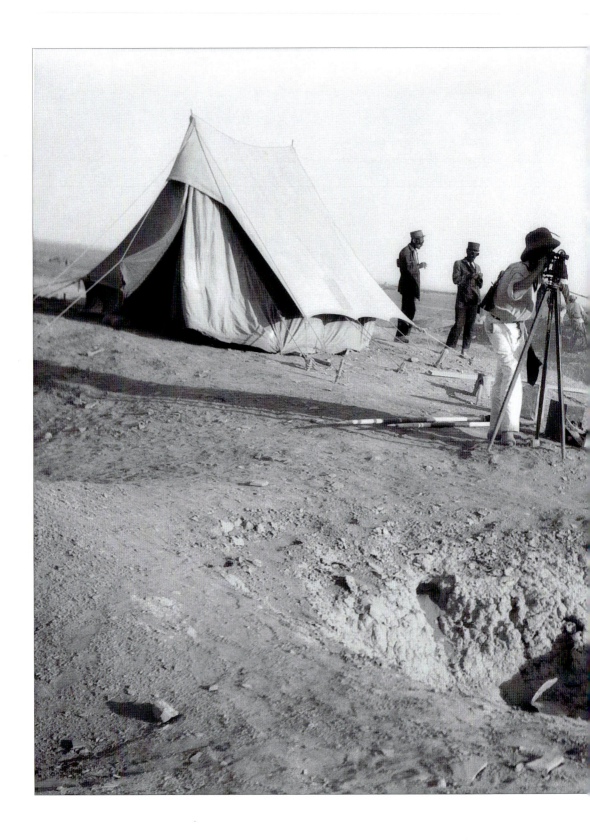

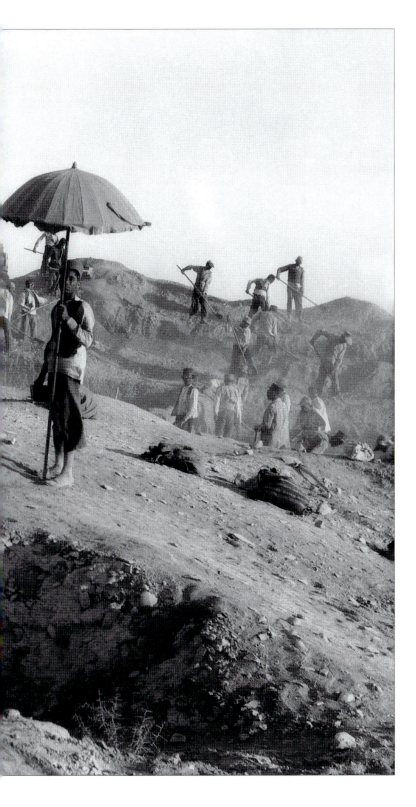

Figure 25. Schmidt using transit survey equipment at Hissar, with the help of a young worker.

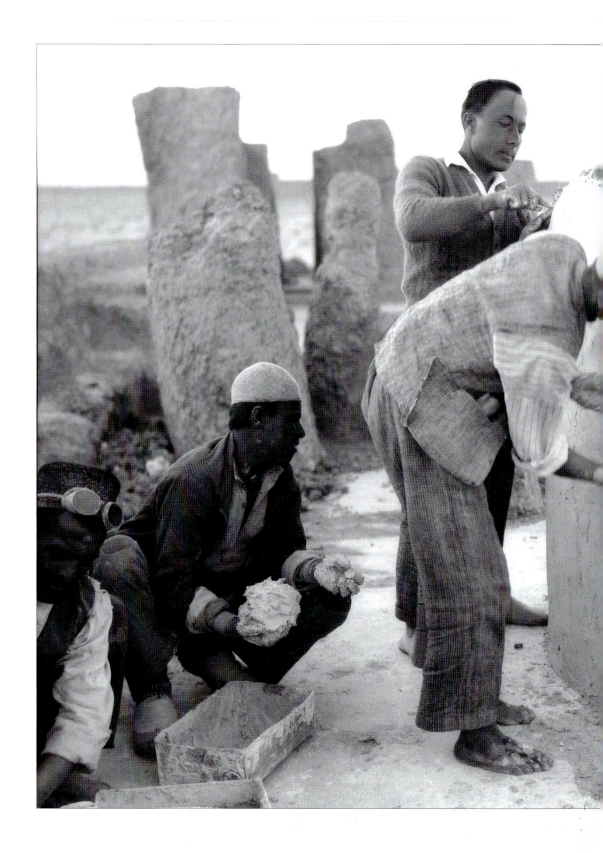

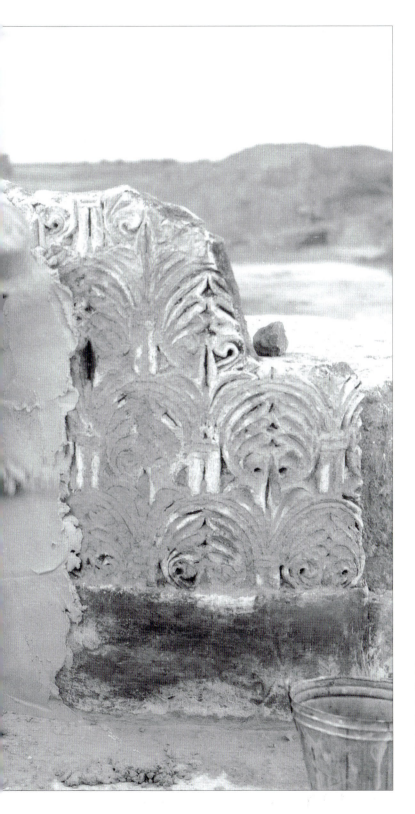

Figure 26. To preserve the column before removing it, Schmidt and a workman plaster gypsum stucco on a 4th century AD column from the Sasanian Palace excavations. October 1931. Neg.#82958.

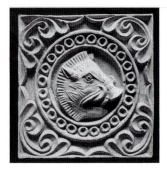

Figure 27. A gypsum plaque of a boar's head in a beaded circle enclosed in an ornamental square frame, 44 x 44 cm. December 1931. Schmidt noted that all plaques and stucco ornaments were formed by moulds (1933:456). Neg.#84530.

seals of stone and clay, lapis, gold, carnelian beads, and bracelets of silver and bronze [Figs.30,31]. They found five exquisitely modeled mouflon heads in sheet gold as part of the hoard on Treasure Hill. They found hundreds of intact ceramic vessels, restored the broken ones, and recorded them. They displayed a large corpus of selected objects in the excavation house museum until Schmidt and the Iranian authorities completed the division of all the objects.

As an anthropologically trained archaeologist, Schmidt was primarily interested in writing a cultural history of the region in order to evaluate objects in their spatial and temporal contexts. In that sense he was revolutionary for his time when most Near Eastern excavations concentrated primarily on object retrieval without detailed attention to context. At Tepe Hissar Schmidt had his surveyor Kurt Leitner draw a topographic map of the mound and applied 10×10 m^2 grid system to excavate the plots. They managed to record the burials and the objects found in these plots in their relative stratigraphic positions and cultural context. His ultimate goal was to establish a relative chronology for Tepe Hissar and the region which could later be translated into calendrical dates. We can glimpse Schmidt's systematic approach from the letter he wrote to Jayne in June 1932:

> On the Main mound I am stripping and sectioning downward to get the main buildings of Stratum II, and of Stratum I, the painted pottery stratum, . . . an important structure [on North Flat], actually palatial for its time, destroyed by fire about 2000 B.C. [Hissar III, end of the settlement], and full of everything we can be wishing for. . . . Alabaster pedestals, large disks, and vessels of the same material are exquisite. There is a corner that produces daily hundreds of ornaments of gold, silver and agate or

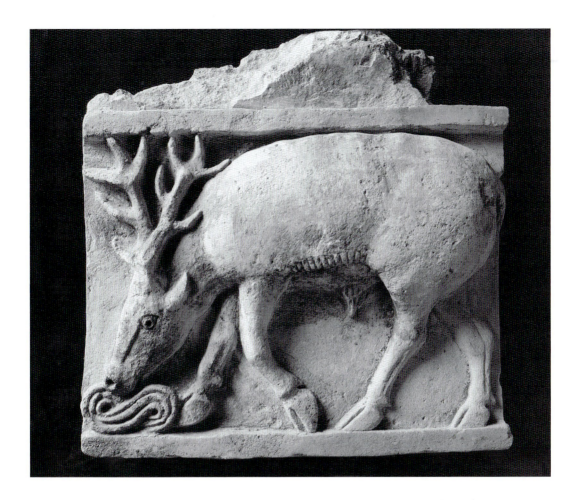

onyx beads and ornaments. This building is a veritable treasure box.

In 1976 Dyson and his team, however, brought more precision to the dating and sequence of the settlement levels. Contrary to Schmidt's hypothesis of cultural changes being brought in by outside populations in the mid–5th millennium BC, Dyson suggested that cultural changes had already occurred in earlier periods, based on ceramic style and radiocarbon dates and, therefore, could only be considered local changes, and/or acquired through east-west trade contacts on the plateau (1989:108–109).

Schmidt's broad cultural framework for northern Iran remains unchallenged. The excavation of such a

Figure 28. A gypsum plaque of a stag drinking water, from the Sasanian Palace. 36 x 32 cm (Schmidt 1933:Pl.CLXVI). December 1931.

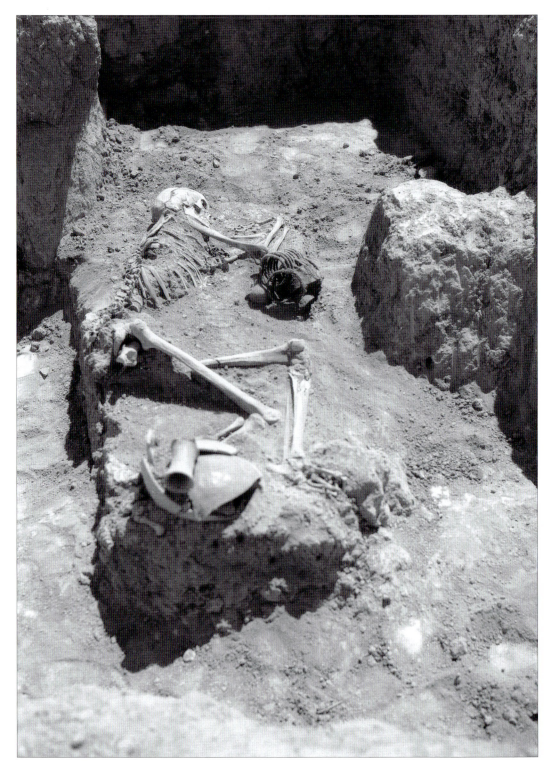

Figure 29. Grave of the "Dancer" (Schmidt 1937:234–35). December 1931. Neg.#83510.

large number of burials within two seasons forced him to shift his goal to the efficient retrieval of thousands of objects rather than the clarification of the exact position of the graves in relation to the settlement. Thus, he did not achieve chronological precision of the Bronze Age settlement, which would wait for a later generation of archaeologists to accomplish.

Closing the Tepe Hissar Excavations

By mid-December 1932 work at Hissar was winding down, and the expedition staff was putting in 15-hour days to finish reports, drawings, and last-minute photos of objects. Schmidt had prepared four leather-bound albums of expedition photographs, one for the Shah and the other three for his Minister of Court, Mr. Teymourtash, for the Minister of Education, Mr. Yahya Khan Gharagozlou, and for Mrs. Thompson. The albums were a gesture of Schmidt's gratitude to the Shah's government that had given him permits to test as many as six sites, in addition to the original two. The prefaces in the gift albums for the Shah and his Minister of Court, written in Farsi, read:

> Presented to His Royal Highness Reza Shah Pahlavi (who is allied with might and destined for Power), May God perpetuate his reign and kingdom, in gratitude for his Royal support and favors to the members of the Damghan Expedition. Director of Damghan Expedition in Iran: Dr. Schmidt, Dispatched from Philadelphia.
>
> This is a humble gift presented to His Excellency, the Minister of the Royal Court of Pahlavi, Mr. Teymourtash, may God extend his Greatness, on the occasion of the inception of archaeological ex-

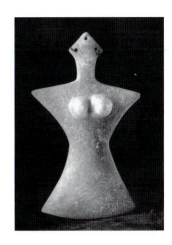

Figure 30. Alabaster stylized female effigy, Hoard III, Treasure Hill, c. 2000 BC. October 1932 (Schmidt 1937:191). Neg.#84776.

Figure 31. Alabaster vase found in the grave of a warrior; translucent, greyish white with light brown bands, c. 2000 BC. October 1932 (Schmidt 1937:215). Neg.#85199.

Figure 32. Prefaces to the photographic albums presented to the Shah and Mr. Teymourtash, the Minister of the Court. March 1932.

cavations in Iran made possible through his patronage of this mission and also in remembrance of his honorable presence at the exhibit of the excavated antiquities in the Ministry of Education.

> With Sincere sentiments of gratitude,
> Director of Damghan Expedition: Dr. Schmidt
> Dispatched from Philadelphia 1932
> [Fig.32].

All along Schmidt had used a policy of discreet politics with the government authorities. After the Damghan Project the Iranian government would reward his discretion by providing him permits to excavate other important sites—Rayy and Persepolis, sites in Luristan, and his famous aerial reconaissance flights.

At the end of the second season, on an icy January morning in 1933, the expedition staff left Damghan for Tehran. They loaded a total of 73 crates of a cubic

yard each of objects and skeletal materials from the second season of the Damghan Project onto three 3-ton hired trucks for overland transport to the two museums in Philadelphia, after the inventory had been divided by Tehran Museum officials. Meanwhile the chauffeur drove the expedition Ford with the staff [Figs.33,34]. Hoping to return to Tepe Hissar and the region, Schmidt had stored most of the equipment in the house and hired a workman to guard the site. After spending a month in Tehran for the division of objects and fulfilling some social obligations, the staff was ready to depart.

By then heavy snowfall blocked the roads, higher than a meter deep in ice and snow. The Ford had to cross 2,500-m high passes. Fighting the wind, while making hairpin turns and shoveling snow through the night, they reached Kermanshah via Hamadan. It took them nine days to cover about 600 miles (1,000 km) to the Iran-Iraq border. Schmidt and company then drove to Baghdad, where Schmidt and White crossed the desert to Damascus in a hired transport trailer bound for Beirut, where they began the last leg of their return journey—White on a steamship back to the United States and Schmidt to Europe, before returning to the United States. Meanwhile, another ship from the Mesopotamia/Persia Corporation (Mespers) was in charge of transporting the priceless objects from the Damghan Project to the University Museum by way of India to England, then across the Atlantic to Philadelphia.

SCHMIDT, THE PASSIONATE EXPLORER

Schmidt's professional life spanned a 40-year period, from his first job at New York's American Museum of Natural History in 1924 to his semi-retirement from the University of Chicago as research professor several years before his death in 1964. He dedicated a full 15 years to fieldwork, starting in Arizona, then in Turkey, Iraq, and

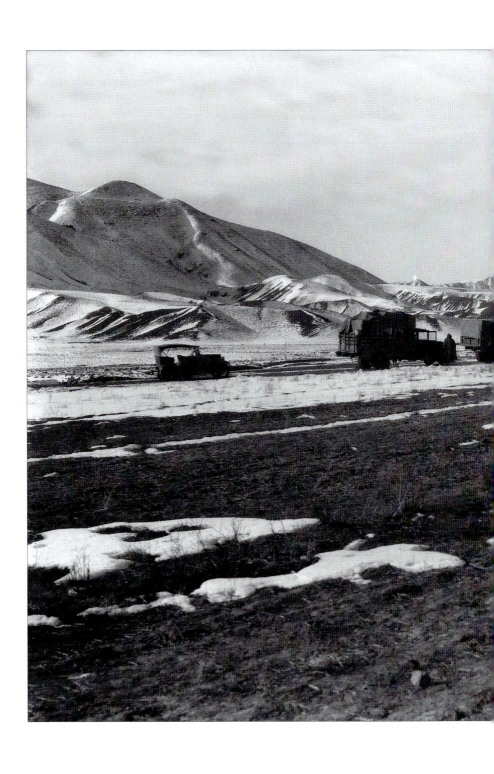

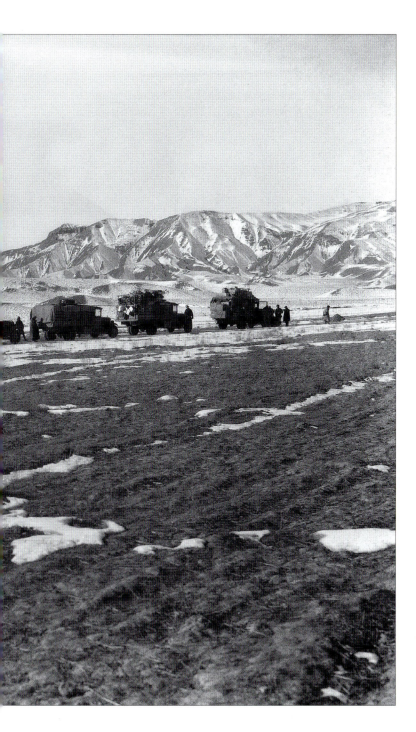

Figure 33. After the first season of the expedition convoy heads for the Elburz Mountain pass of Firuzkuh on its way to Teheran. December 1931. Neg.#83111-17.

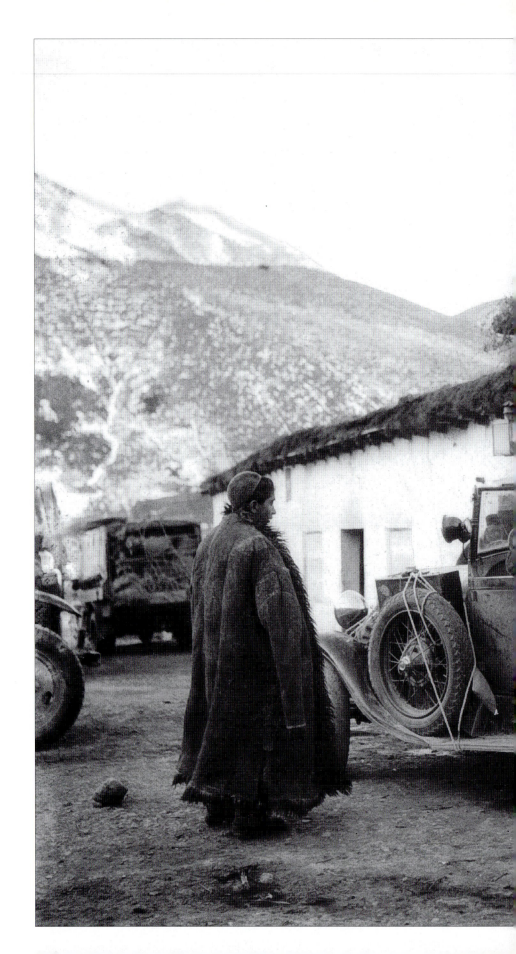

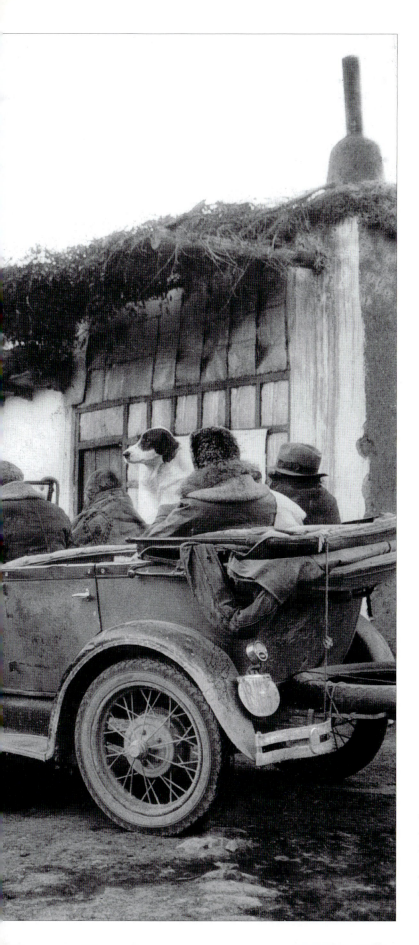

Figure 34. Convoy of cars en route Damghan-Tehran at the end of the second season. "Wolf" succeeds in positioning himself in the expedition car, next to Schmidt. January 1933. Neg.#83993.

Iran; after 1939 he concentrated on his writing and research. At the time of his death he was writing the last volume on his excavations at Persepolis (1935–39).

Neither Schmidt's professionalism nor his ability to cope with the vicissitudes of fieldwork can be disputed. He attributed his organizational talents largely to his army training. In several of his letters to friends he wrote: "Pfluecke die Rosen kuehn, die Dir am wege bluehn" (If I don't blow my horn, how will you hear me?). We do not know what his staff thought about his horn blowing, but he was known to fall into fits of anger if his staff did not adhere to his work schedule. On the other hand, he appreciated and awarded extra pay to Niedzwiecki, his head photographer and artist, who did outstanding work. In one of his reports to the Museum in 1931, Schmidt referred to Niedwiecki as having an "inventive spirit, and an almost 'discouragingly' high artistic photographic standard! He takes many pictures himself, and prints those taken by the staff members." Yet Schmidt soon dispensed with Niedzwiecki's talents because of his slow pace, and assigned Dubensky, the assistant photographer, to take over the job. Schmidt seemed always to be fighting against time and funds to finish the tasks he set himself; yet he did have a lighter side, which he implicitly referred to in his letters to his friends. In an account of his work in 1927–29 in Turkey he summarized the ideal attitude at an archaeological camp:

> good work and good fellowship. . . . But there is a humorous and hearty camp spirit dear to every field man and much more sincere than mere social politeness. . . . [at Hissar] After a few months in camp, the monotony of the landscape and the routine of a life without much variation may depress one. Thursday nights were safety valves for grouches that might have accumulated during the week. On these nights, the

Moslem weekends, we got together and said what we thought of one another. This we found to be a wholesome arrangement. (Hohmann and Kelley 1988:6)

He was a man of humor and irony, a romantic, but always with a deep streak of realism and commitment to his work. At one point finances were so dire that he had to take a break from Hissar and go to Paris to request funds from Gertrude Thompson. His letter of October 9, 1931, to Jayne illustrates his continued attempts to obtain funds for his projects in his quietly passionate, fanciful style:

> I met her [Mrs. Thompson] in Paris hoping that she would increase the somewhat slim budget. For two days I painted Persia with words of the color of a mirage with mosques and minarets silhouetted against the background, precious rugs draping the sides, cool scented gardens filling the center, and Persia's past rising from deep trenches in the foreground! Allah made me speak the right words—it was 6 o'clock in the morning, a damp and cold Paris morning, when I finally went home, from Montparnasse to Montmartre, with Mrs. Thompson's check [for $10,000] in my pocket. I was perfectly happy; but I got a cold that lasted three weeks.

Schmidt felt that the physical and psychological well-being of his staff was important. We owe Schmidt's extraordinary photo collection to some of these trips with his staff [Figs.35–38].

On December 5, 1932, Schmidt wrote to Jayne: "Leitner, the best topographer I ever had, was personally a failure. His absence, some trips to Teheran and the exploration trips kept the staff fit. Last year I neglected psychological breaks and people became stale. Lockard and

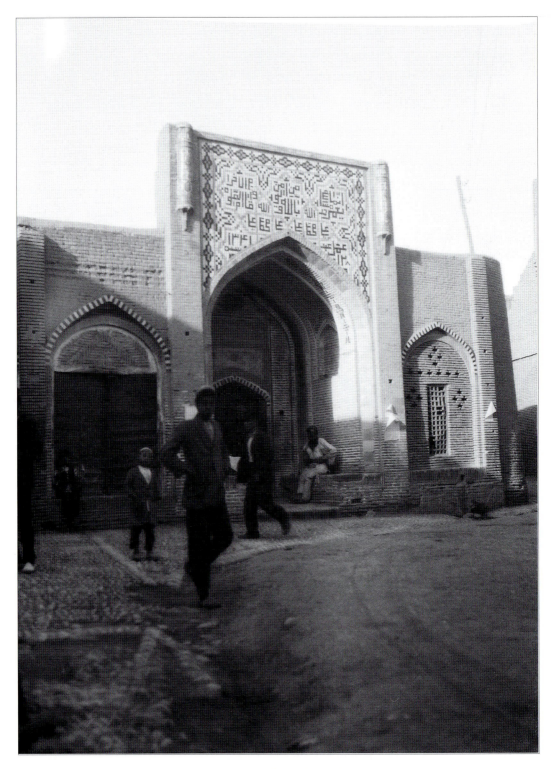

Figure 35. A monumental mosque near Damghan. 1932. Neg.#83413c.

Figure 36. Town of Dizful in Khuzistan province, near the site of ancient Susa in southwest Iran. Entrance to the bazaar, flanked by small shops. It is now the trade center for an irrigated farm region where petroleum is produced. March 1932. Neg.#83413.

White are doing well, and my Russians artist, photographer and restorer are unfailing dynamos of industry."

Despite long hours spent working in the field and at the house, life was not without its occasional excitements, playing bridge and chess and entertaining visitors. Dinner parties for Iranian officials and visiting colleagues were enjoyable social events that broke the monotony of work. Schmidt referred to them as "a friendly gesture and good politics," occasions for socializing as well as keeping officials informed about the work.

One of the highlights of the season was receiving visitors from Philadelphia—Mrs. Clarence A. Warden, her two daughters Mary-Helen and Adele, and Miss Louise Catherwood—who had flown in near Damghan on a rented airplane. Erskine L. White entered a vivid description of the visit in his memoirs:

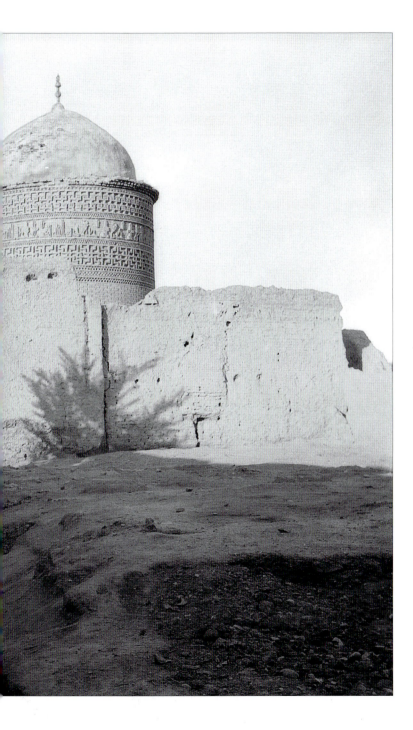

Figure 37. A tomb tower built for a saint called Pir Alamdar, c. 10th century AD, Damghan. July 1931. Neg.#82826.

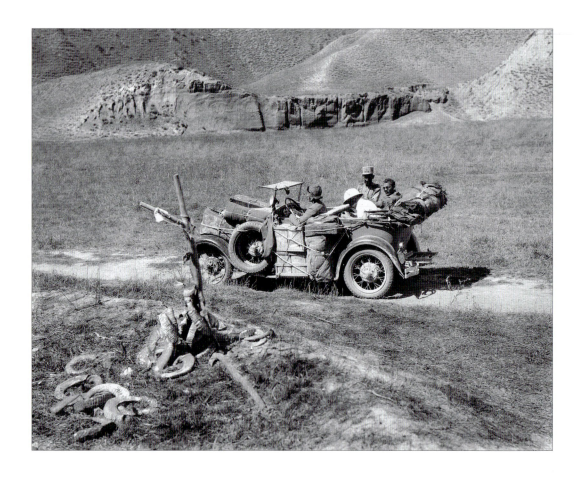

Figure 38. The site of a mound Muravei tepe and a Seljuk tomb tower Gunbad-i Qabus (background), located 10 miles (16 km) south of the Turkmenistan border. On left foreground, note rams' horns next to a tree branch signifying the spot where someone had been killed. September 1932. Neg.#83900.

We started the entertainment with caviar [from the Caspian] sandwiches and coffee in the museum [a room in the expedition house where a collection of the finds were displayed]. This was followed by the best luncheon we had had. It was well served by three butlers. The victrola records had been gone over and another servant played soft music while we ate. Shortly after lunch our visitors took an hour to rest . . . they had left us an album to write in. Instead we pasted photos in it. In the center our most grotesque skeleton, across the top the unholy three, Lockard, Schmidt and White. Around the center we put the rest of the crew and across the bottom the animals. . . . At 7:00 a.m. we left for the Tepe where we showed all we had done. . . . After they took movies and stills, they packed and we went in two cars to

the "airport." I think the entire village turned out to see the excitement. (1982:30)

Little is known about Schmidt's private life other than his great interest in chess and languages. He spoke six languages—English, German, Russian, French, Farsi, and Arabic. Before launching the Damghan Project he had been very concerned, with good reason, about being able to make a living as a field archaeologist. His initial affiliation with the Oriental Institute had been very tenuous. It ended with his resignation from his position as co-director of the Alisar excavations, sponsored by the Oriental Institute, due to professional disagreement with Hendrik von der Osten, the excavation director. Schmidt expressed his concern in a letter in 1930 to Mr. Kelleher, the Thompsons' secretary:

In case I would not stay with the Oriental Institute, I would have to attach myself to an institute like the Carnegie in Washington, and I would take up Peru. In case I could not find a patron or patroness to get me over the beginning there would be just one thing left: to turn a scientific tramp! I would not kick about it. I would happily sell all the things I have and go wandering like one of those medieval scholars. But I would not have the material possibilities for doing the work as thoroughly as I do.

When Jayne offered Schmidt the Damghan Project he was ecstatic; he was totally prepared to make the leap of his life to what he called the "exotic East." In a letter to Jayne on July 12, 1930, he wrote: "I am accepting your offer, and I am very eager to fully justify your trust and your expectations as to my abilities. I like the cheerful and dynamic spirit which now prevails in the University Museum, and which guarantees enjoyable cooperation between

head quarters and the field staffs. I am a field man, and I am grateful to you for giving me the opportunity to do that work for which I care more than for anything else."

He was thrilled by the "hunt," the new opportunities for field exploration. But his anxiety about securing a permanent position at an institution, with a guaranteed salary, is a recurring theme in his correspondence with Jayne. In November 1936, six years after his joyous letter of acceptance to direct the Damghan Project, he wrote to Jayne to express his concern once again:

> In case the Iranian work is discontinued, the Museum of Fine Arts, Boston, and the Oriental Institute will cease to be sponsors of the expedition. My own salary was paid by those institutions and will also be discontinued. I do not like to be paid out of the contribution of Mrs. Thompson nor do I ever want to draw funds for my personal expenditures from Mary-Helen's foundation for aerial research. For this reason I ask you whether the University Museum is able to contribute the amount of Dollars six thousand per annum, namely, the equivalent of my salary. I want to be personally independent and I want to be free to contribute the surplus of my own remuneration to the work in my own way.

The files do not include Jayne's answer to this letter.

Over the next six years after the Damghan Project, 1933–39, several museums and benefactors in addition to the University Museum supported Schmidt's work in Iran, and he also won a respectable offer as a research professor at the Oriental Institute of the University of Chicago.

Schmidt seems to have left no memoirs or personal papers. Several of his obituaries stated that he was married twice. His first wife, Mary-Helen Warden of Ardmore, Pennsylvania, died in childbirth in 1936, only

two years after their marriage. In one of his letters to Jayne, May 10, 1934, Schmidt thanked Jayne for having been his "best" best man at his wedding, and continued, "Mary-Helen is doing wonderful. There is no craving for any social life or greater comfort. She is sticking right to her job as camp-superintendent and head of cleaning and repairing. She is a grand companion." He later alludes to Mary-Helen's happy disposition in the field and her skilled work in mending pottery and restoring textiles at the Rayy excavations. During most of the early reconnaissance flights Mary-Helen had accompanied the team, except when Schmidt had to be treated for malaria and an infected old wound and she had stayed behind to take care of him at the Persepolis excavation house.

A few months after Mary-Helen's death, which must have been a great loss for Schmidt, he petitioned for citizenship and in 1937 became a naturalized citizen of the United States of America.

In 1945 Schmidt married Lura Florence Strawn, of Ottawa, Illinois. They had two children, Richard Roderick and Erika Lura. In 1960 the family had moved to California, though Schmidt continued to return to Chicago intermittently for research and work on his manuscripts. Suffering from a lung ailment for years, he died in his home in California on October 3, 1964, at the age of 67.

Haines (1965) and the *National Cyclopaedia of the American Biography* (1969) note Schmidt's numerous honors and scholarly affiliations.

THE FLIGHTS

Schmidt's aerial explorations are of singular importance in archaeological research for that period, as they clearly opened a new era in survey methodology in re-

cording sites that could be easily missed during land sur-
veys. In the 1930s aerial surveys were very rare—a couple
of examples are Père Antoine Poidebard's aerial survey of
Roman walls in Syria and Colonel Charles A. Lindbergh's
and Alfred V. Kidder's discovery from the air of Maya ru-
ins in Central America. Schmidt's flights encompassed
almost all of Iran from Rayy to Persepolis to Luristan
in 1935–36. His last three flights were over Azerbaijan
in the northwest, the Turkoman Plain, Damghan and the
Asterabad plains in the north, and Luristan in the west
(see map, p. 102).

Schmidt launched a well-planned, extensive program
which was funded through the Aerial Research Founda-
tion established by Mary-Helen. Schmidt and his loyal
photographer, Boris Dubensky conducted the surveys
conducted from the camera-equipped Waco cabin twin-
engine plane christened "Friend of Iran," flown by Lewin
B. Barringer in 1935–36 and William G. Benn in 1937.
Frederick Lillich was its mechanic and technical assistant.
In accordance with the permit a Lieutenant of the Iranian
Air Forces accompanied the flights [Fig.39].

The aerial photographic operations had three com-
ponents—flights over excavations already in progress, the
aerial documentation and mapping of sites, and reconnais-
sance flights over Iran's archaeologically unknown areas.

Flying over sites provided a more comprehensive
view of the terrain and its topography, essentially what
Schmidt had missed in his land surveys. In a letter of April
4, 1936, to George Edgell, director of the Boston Muse-
um of Fine Arts, Schmidt outlined his well-planned flight
strategy for a combined air and land survey over Pasarga-
dae, Cyrus the Great's capital near Persepolis: "During our
last flight we circled again over Pasargadae. . . . There are
some awfully good-looking hillocks which have yet not
been touched, close to two white fire altars. In a few days,
on our return flight to Tehran, I shall take aerial photos

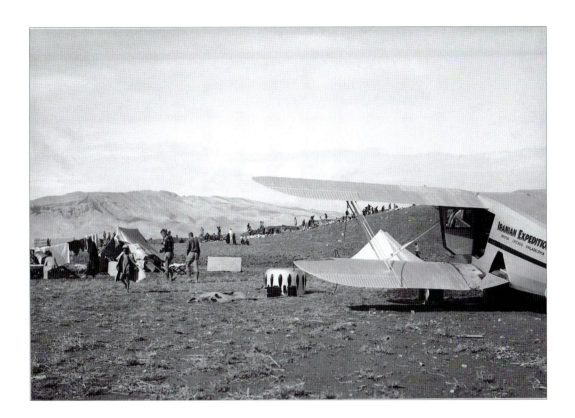

Figure 39. Setting up camp for excavations at the mound of Chekha Sabz, Luristan, western Iran. The site "revealed interesting objects of the 3rd and 1st millennia BC" (Schmidt 1940:48). May 1935.

and analyze the deposits by means of enlargements. Then we shall make a trip overland and check up" [Fig. 40].

Aerial documentation was also cost efficient. While the Rayy and Persepolis expeditions were in progress, Schmidt would be shuttling from one to the other in 4 hours, a distance of nearly 960 miles (600 km), which would have taken two days by car to cross. In one long flight of 13 hours Schmidt had pinpointed and documented an overwhelming number of 400 sites around Persepolis. At times he would fly his staff to see a bird's eye view of the excavations in progress. He had also discovered that he was able to draw, with some accuracy, the topographic map of a site from its aerial photo, showing excavation plots, provided that the photographs corresponded to excavations on the ground. To match them, he marked base points on the ground, using quadrants of 100 m squares, subdivided into 10 x 10 m excavation plots, as he had done previously at Tepe Hissar. Then, on

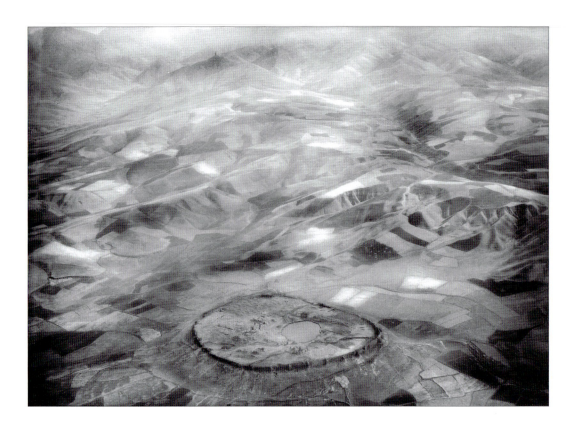

Figure 40. The ruins of Takht-i-Sulaiman (Throne of Solomon), center. July 1937. "Built on a natural elevation, it includes structures from the Parthian period or earlier to Mongol times. Its greatest splendor falls in the time of the Sasanian empire" (Schmidt 1940:87).

the air photo showing these base points, he could draw lines to connect points to excavation plot lines. The result was a grid of squares from which the excavator could determine quickly and accurately where to start digging.

These surveys represent the culmination of Schmidt's archaeological knowledge and experience, his insights about the geographic diversity of the Iranian landscape and its historical depth. They also demonstrate his innovative spirit and his perseverance to realize his idealism against the political realities of the period. In a letter to Edgell, July 10, 1935, Schmidt referred to the permit to import the plane into Iran: "the most difficult task of my archaeological career, namely the realization of the Aerial Department of the expedition." After two refusals from the Shah Reza Khan while the plane was grounded in Alexandria, Egypt, Schmidt finally received a permit to import the plane and approval for his flights, after he had hosted the Shah and his son in Persepolis, following

persistent efforts of high-ranking bureaucrats in Iran and those in the U.S. State Department (Majd 2003:223-37).

Having accomplished the monumental task of an extensive aerial reconnaissance, in 1940 Schmidt published the results in *Flights over the Ancient Cities of Iran* and dedicated it to his first wife, Mary-Helen. It is an impressive, linen-bound folio, now out of print. In the "Retrospect" section of the book Schmidt wrote: "the flying archaeologist gains infinite joy and satisfaction from his combined tasks in the air and on the ground" (1940:95).

The *Flights* book is an invaluable documentation of sites as well as a photographic oeuvre of striking artistry. Its black-and-white photographs recreate certain moods of a landscape, in shades of gray against nuances of light and shadow. He captures the sites in their total environment, including geographical, geological, and archaeological features [Fig. 41]. Along with an introductory text, detailed captions provide each photograph with a name, date, altitude, latitude and longitude, weather conditions, and even time of day when taken. Dubensky and Schmidt took the aerial photos as "vertical" and "oblique" views to complement and enhance his previous ground surveys of some of the same regions. Sometimes the flight crew was able to land the plane near a site or so close to it that they could combine observations from air and ground.

Each day Schmidt and his crew started the flight before sunrise in order to catch the best light conditions within the next 2 hours. He noted that "the ground survey, requiring several months and considerable expenditures, is displaced by the air map, complete in a few days, or, if need be, in a few hours" (1940:95). He summed up his method of combined observation in the Retrospect section of *Flights*: "The vertical air view gives the excavator his map, and he can plan his operations intelligently. . . . Surface clues often invisible from the ground but seen from above guide the explorer in his overland voyages. . . .

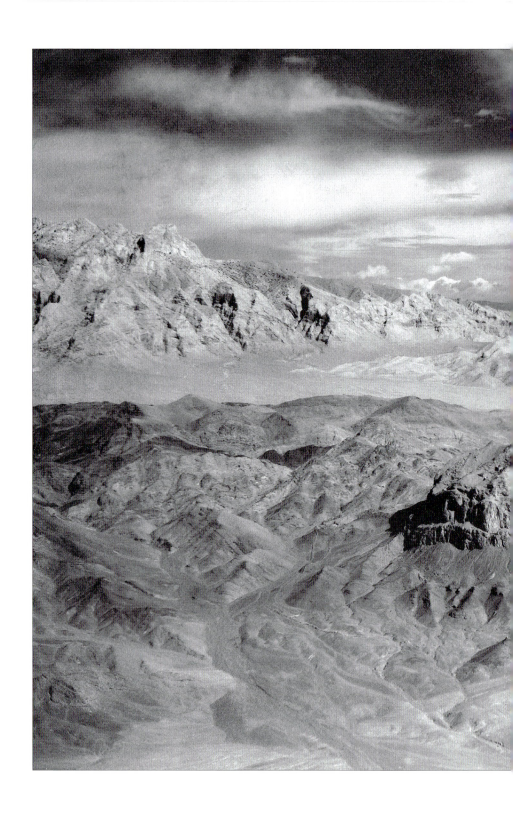

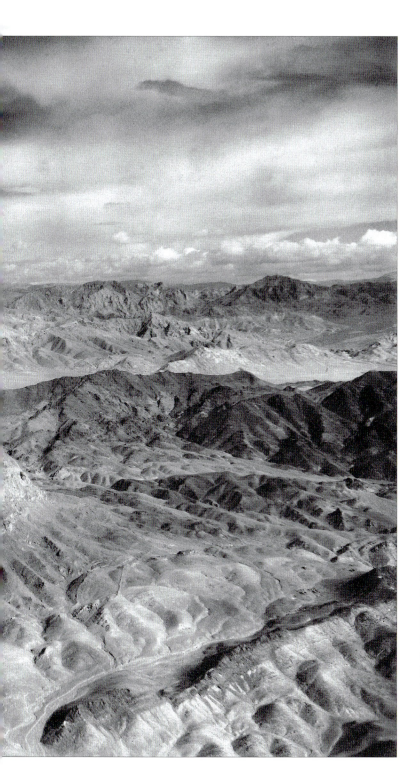

Figure 41. "Girdkuh, A Fortress of the Assassins, beautiful though sinister are the landscape and even the very sky which form the very setting for the cylindrical rock once crowned by a castle of an infamous sect" (Schmidt 1940:47). It is located in Qazvin province, west of Teheran. Viewed from an altitude of 333 ft (305 m). September 1935.

Our eyes have become trained to see remains of antiquity where formerly we disregarded odd discolorations of the surface of the earth."

These aerial photos are as dramatic as they are useful records of sites in uncharted territories, some situated in wildly rugged terrain which even Schmidt's Luristan expedition members would not have dared to enter.

SCHMIDT'S CONTRIBUTIONS TO NEAR EASTERN ARCHAEOLOGY

Many scholars maintain that the 1930s were a turning point in Near Eastern archaeology, a period of transformation from treasure hunting to establishing a systematic academic discipline. Schmidt unquestionably contributed to that transformation. As a pioneer in applying systematic excavation and recording methods, conducting regional surveys rather than concentrating on a single site, he was essentially interested in writing a comprehensive cultural history of the regions where he worked. To him descriptions of excavated objects, their technology, and the materials from which they were made were as important as their cultural and environmental contexts. He enlisted geologists and other experts to analyze metals, seeds, and human and animal bones in order to provide "scientific" evidence to support his interpretations. Few archaeologists of his generation understood, as he did, the importance of uncovering prehistoric sites in a region so as to investigate the prehistoric cultural predecessors of the historical sites of monumental dimensions. Such examples of Schmidt's work are the prehistoric site of Tal-i Bakun in south-central Iran, dated to the 4th millennium BC (already tested and excavated by Herzfeld in 1928 and 1932), situated only 3.2 miles (2 km) from the monumental palace of Darius at Persepolis; the Islamic city of Rayy and its prehistoric predecessor, Chashmah Ali, near Tehe-

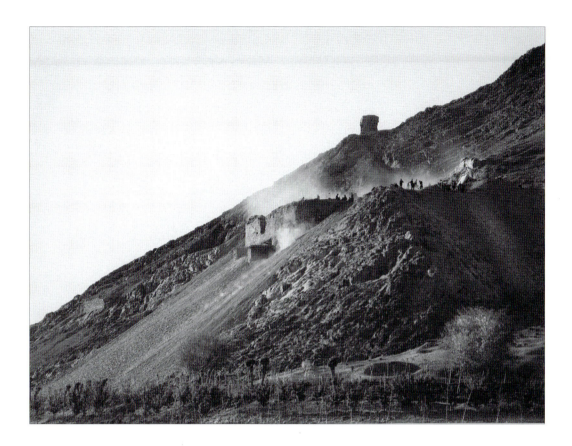

ran [Figs. 42,43]; and other Islamic sites in the environs of Rayy [Fig. 44] and several sites in Luristan [Fig. 45].

Although he did not clearly achieve stratigraphic precision at Tepe Hissar, Schmidt managed the careful retrieval and timely recording of many thousands of objects, with their general find spots and associated architectural features. He published both seasons of excavations at Tepe Hissar and the Sasanian Palace in a timely manner (1933, 1937). Even though there is still a considerable amount of unpublished material from Hissar, the Damghan Citadel and other smaller nearby sites where Schmidt did test excavations, his documents about these sites in the University Museum Archives provide a rich corpus of archaeological evidence that forms the basis for reconstructions of these sites and regions in the future.

Schmidt's later work in Iran after Tepe Hissar and the Damghan Citadel was marked by equal success. Ac-

Figure 42. "Grand view of Naqarah Khanah site during excavation of a royal tomb of Seljuks at the outskirts of Rayy," near Teheran. April 1936 (Schmidt 1940:36).

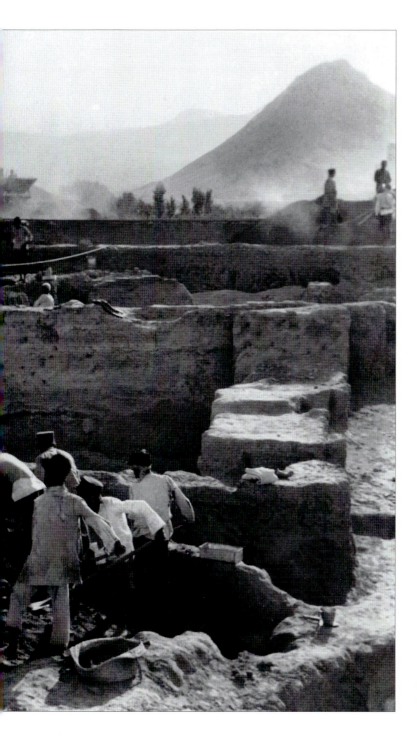

Figure 43. Excavations at Islamic Rayy.

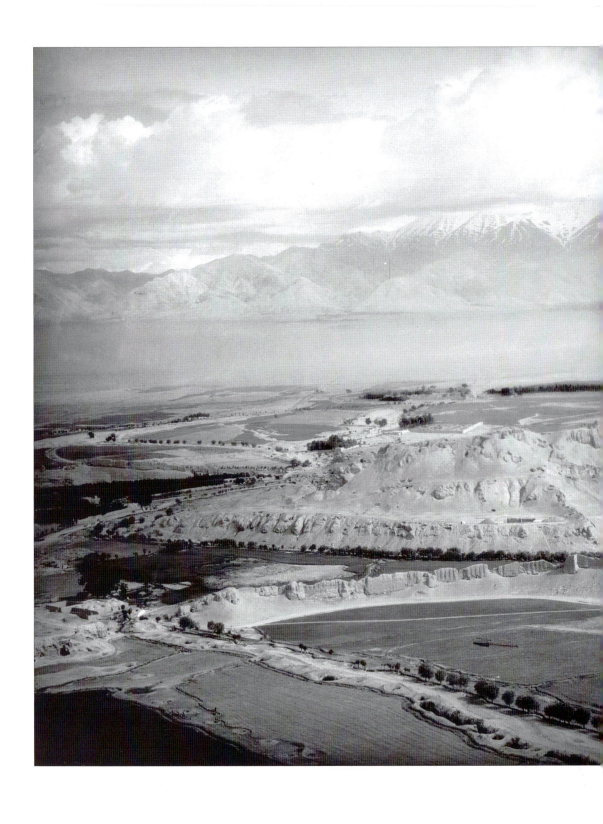

Figure 44. "Oblique view of the citadel of Rayy. The main part of the citadel is in the center" (Schmidt 1940:31). May 1936.

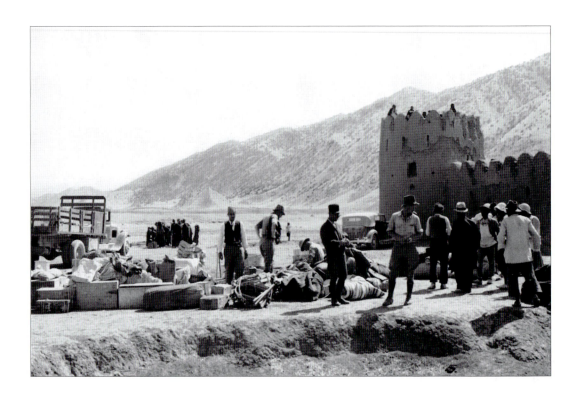

Figure 45. Arrival at camp site near Zogh Ali, Luristan. April 1935.

companied by Mary-Helen, he returned to Iran in 1934 with renewed energy and stayed there until 1939. Some scholars consider the crowning achievement of Schmidt's career to be his last three expeditions, to Persepolis and Luristan and his pioneering aerial explorations over Iran. Maurits van Loon paid tribute to Schmidt in his Foreword to *The Holmes Expeditions to Luristan:* "he was one of the last excavators of the heroic age in archaeology. Some of his qualities were those of a general, as when he directed the expedition's twin-engine plane, five horses and sixty-five donkeys"(Schmidt, van Loon, and Curvers 1989:xv) [Fig.46].

Schmidt ran these expeditions concurrently, flying from one to the other. Even though the book-keeping itself had become enormously detailed and complicated, he managed to send his reports from the field regularly to the supporting institutions. While the aerial survey was funded by the foundation established by Mary-Helen, the excavations and tests at sites in

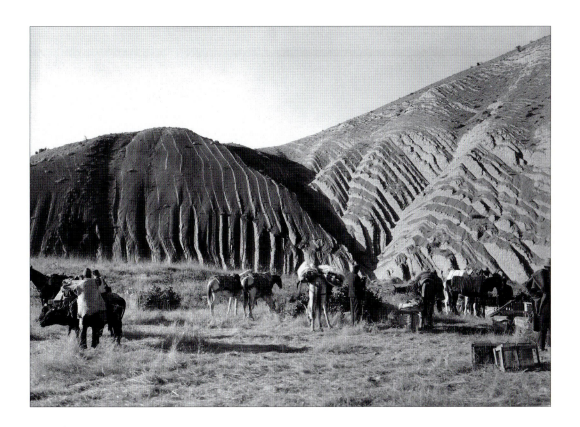

Figure 46. Near Tang-e-Malawi, Luristan. The pack trip of the expedition crew starts.

Luristan, Persepolis, and Rayy were jointly sponsored by the University Museum, the Oriental Institute, and the Boston Museum of Art.

Schmidt took over the Persepolis excavations in 1935, after Herzfeld had resigned, allegedly because of disputes with Iranian officials over his delayed permit. While Jayne had not warmed up to the idea of undertaking this project, Schmidt insisted, and with funds secured from Mrs. Thompson in the amount of $45,000, channeled through the University Museum, he continued to work there until 1939.

At Persepolis Alexander the Great had burned the 6th century imperial palace of Darius I in 330 BC, after which it remained buried under thick layers of ash until the first serious excavations were undertaken by Herzfeld in 1931–34. Schmidt concentrated on cleaning and restoring the sculptures and reliefs, excavating and making detailed studies of the royal enclosure, including the palace fortifications, the *Apadana*—a columned reception hall—the harem, and

the treasury [Fig.47]. He published his Persepolis work in three volumes of which the first was presented by the Oriental Institute to Elizabeth II of England on the occasion of her visit to the University of Chicago in 1959. Two decades earlier, Persepolis had been the scene of another royal visit, then by Shah Reza Khan and his son Mohammed Reza. At that time Schmidt's motive had been to impress the Shah with the splendors of Persepolis excavations so Schmidt could then gain the favor of a permit to conduct his aerial surveys. He described the Shah's reception in an elaborately detailed letter in March 1937 to John A. Wilson, Director of the Oriental Institute:

The expedition house received particular attention. The large doors at either side of the beautiful columned Main Hall of the Harem were taken down to give access to the neighboring rooms containing the collections from Persepolis and Istakhr [the sacred precinct near Persepolis, site of the rock tombs of Darius I and later kings]. The Persepolis museum was now arranged in dark maroon. Niches and tables were covered with cotton cloth of this color. The Greek statue formed an impressive center piece in a niche while weapons, ornaments, stone vessels, iridescent glass, seals, tablets, coins and other inscribed objects formed groups on pyramids of cubical boxes in the color of the room. . . . Dubensky's beautiful photos decorated the walls and rugs were spread on the floor. . . . The Istakhr museum opened into the Aeronautical Department of Mary-Helen. Here the color of the evening sky prevailed. . . . The center piece was the map of Iran with our flights in red. . . . The aerial camera was on exhibit. . . . All our past endeavors and our future hopes in aerial archaeology were shown in absolutely open manner. The Aerial Department was reserved as the room of H.I.H. the

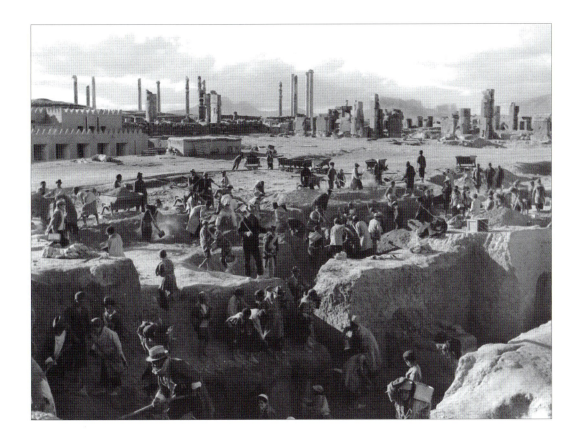

crown prince. My own room, also opening into the Istakhr museum, was reserved for H.I.M.

At 11 A.M. several dust clouds approached speedily, a sharp order from the nearby gendarme post: present arms; the first car stopped. H.I.M. and H.I.H. had arrived. H.M., about 60 gray hair, marked face, hard, soldierly eyes reddened and penetrating, pronounced nose and chin; in uniform, with cane. H.I.H. 18, neat uniform of military school, sympathetic appearance, dignified in spite of his youth, standing usually at respectful attention behind his father.

After Schmidt explained a few of the air photos and the aims of his aerial research, the Shah declared: "I see that the air work is valuable for archaeology." Schmidt continued to impress the Shah with the restored reliefs

from the grand stairway of the *Apadana*: "After the inspection of the museums we went to the new reliefs in the 1936 excavation. H.M. and H.I.H. were quite impressed, by the attractiveness of the entire relief and also by a certain parallelism: There was Darius and his son Xerxes, and the onlookers were again a king [Reza Shah] and his son." This "staged parallelism" and flattery of the Shah, evoking sentiments of his glorious Achaemenid ancestry, gave Schmidt an extension of his permit to fly, well into the year 1937. He ended the long letter in his characteristic triumphant tone:

At 8 o'clock sharp, H.I.M. and H.I.H. appeared at the door. . . . H.M. called Mr. Riazi and told him to express to me his satisfaction . . . with the progress of the excavation so far. However, I should try to work faster . . . I promised I shall try to work as fast as conditions permit. "Results"— The man whose word in this country is law has expressed his satisfaction with the expedition although he knows well enough that it is an American enterprise. [The Shah was not happy about the American involvement in oil enterprises in Iran]. He has endorsed it. H.I.M. has given the permission for an exploratory flight into a military zone, thus expressing his personal confidence.

In 1934 Schmidt conducted a preliminary survey in Luristan, one of his great adventures, physically arduous and operationally very risky. He had found an interesting valley called Rumishgan with "worthwhile sites" which were accessible across a torrential river, through the narrow paths of the rugged Zagros chain. He managed to transport the excavation equipment and the staff on horses and donkeys, to the great astonishment of the Lur nomadic shepherds who helped the group to set up camp in the valley [Figs.48,49].

After that initial survey, there were two expeditions to Luristan in 1935 and 1938 funded by Mrs. Christian R. Holmes through the American Institute for Persian Art and Archaeology and by Mrs. William B. Thompson, whose sponsorship enabled the University Museum, Boston Museum of Fine Arts, and the Oriental Institute to participate as partners.

Schmidt was a dedicated man and a keen observer of the world around him, a skill which would help him solve many of the bureaucratic problems he encountered. A raconteur in the best Old World sense as some of his correspondence reflects, he enjoyed his missions despite physical and financial hardships. Working with him might have been strenuous for his staff, for Schmidt was relentless in his work ethic and expected the same from his co-workers. He wrote to Jayne in December 1931: "any man who wears out or falls short of certain minimum requirements will be sent home." As an untiring archaeologist/scholar and a gentleman, he had gained the trust of important academic institutions and individual benefactors. The University Museum remained his loyal sponsor throughout his work in Iran, along with other co-sponsors, starting with the Fara and Damghan Projects in 1930, to the end of the Persepolis excavations in 1939.

The late Richard C. Haines wrote in Schmidt's obituary: "His death is a great loss to archaeology, for his work was not finished; his life was an immeasurable gain, for his researches provided a basic knowledge of all those areas in which he worked" (1965:145).

My tribute goes to Erich Schmidt, an untiring field archaeologist and scholar whose vision encompassed the wide, unexplored territories of the Near East, uncovering its ancient past without losing sight of its early 20th century humanity. In the end, Schmidt repaid the confidence entrusted in him by a remarkable legacy of work which

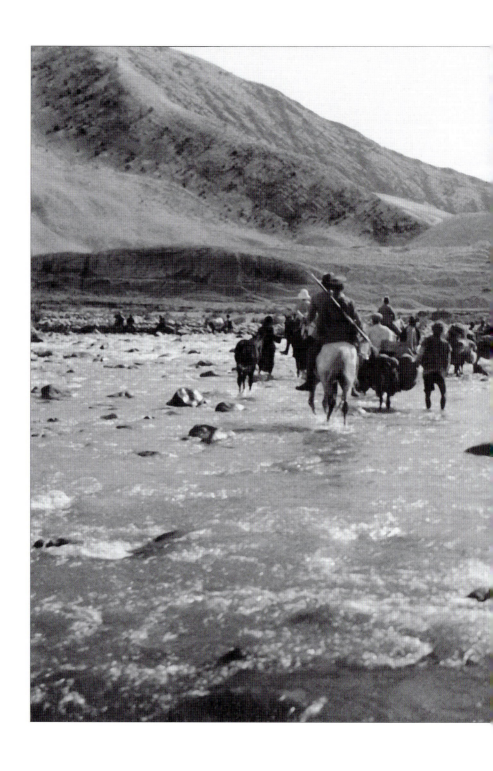

Figure 48. Luristan, near the Kashgam River, 112 miles (70 km) south of Khurramabad. March 1932. Schmidt notes: "Khurramabad was the source of certain supplies for camp. Most of us were tired of turnips. . . . Hence the exploration ship turned into a truck on its flights home from town. Spinach and radishes. . . cabbages, potatoes, melons and bottles of beer, together with tins of Anglo-Iranian airplane gas filled the rest of the cabin"(1940:45). Neg #83400.

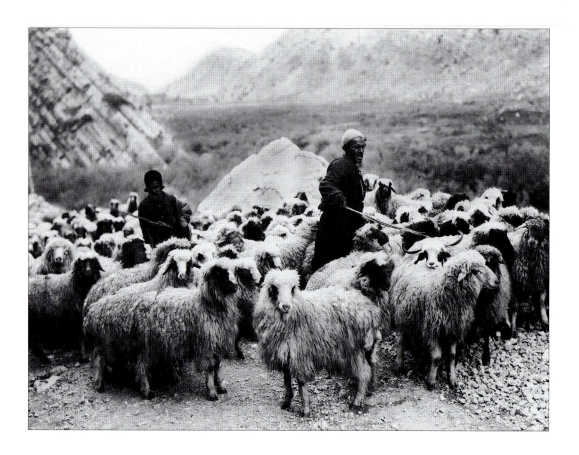

Figure 49. Lur shepherds with sheep crossing the Zagros Mountains, near the village of Saliabad, Luristan. March 1932. Neg.#83409.

he left in good order for future generations of archaeologists and scholars.

The Archival Photographs

Schmidt's photographs encompass one of the largest photographic collections in the University Museum, with some 2,600 contact prints in black and white which are glued into six archival albums. Most of the photos were taken by Stanislaw Niedzwiecki and Boris Dubensky, whose work Schmidt valued highly, and some were taken by Schmidt himself.

The prints measure 2 ¼ x 3 ¼ or 4 x 5 inches, and the negative sizes are 4 x 5 and 8 x 10 inches.

There are also selected enlargements of very fine quality prints, among them some albumen prints, in three leather-bound albums from the Damghan and Persepolis expeditions. They range from 5 x 7 to 11 x 14 inches. The Warden family owned these albums and then gave them to the University Museum in 2002.

Besides their clarity in detail and composition, these photographs are an extraordinary collection of historical information. They give us a comprehensive coverage of behind-the-scenes events of Schmidt's expeditions, his staffing, administration, daily documentation of the excavations, and above all, an overview of research in the region conducted in the 1930s.

It is important to bear in mind that these images are conveyed through the eyes of outsiders, Schmidt and company, people of Western culture, discovering a little-known world. As much as they are the photographers'

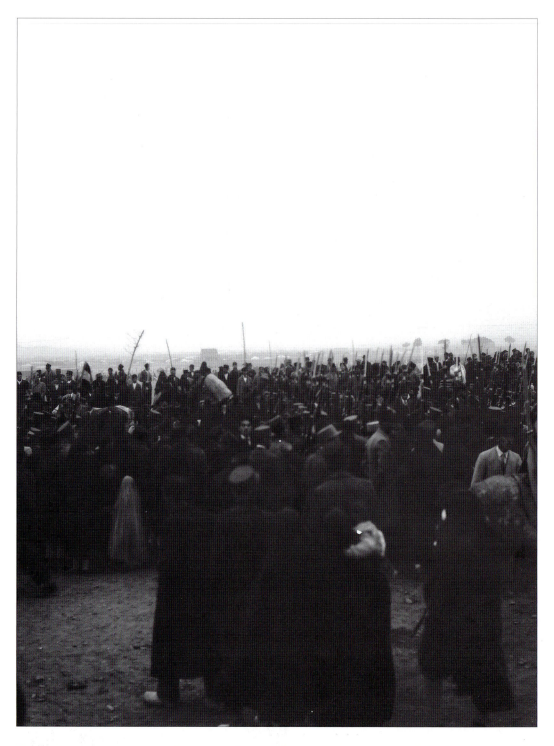

Figure 50. Army review on Coronation Day in Tehran. Civilians wear "Pahlavi külah," named after Shah Reza Pahlavi, who replaced the traditional conical hats worn by the rural people with French military-style brimmed hats. February 1932. Neg.#83126.

Figure 51. Luri men in their regional costumes, in the town of Saliabad, the end of the railroad line in Luristan. March 1932. Neg.#83410.

interpretations, these images are not like the romanticized, orientalizing style of the 19th century photography. Schmidt's collection has a documentary objectivity combined with exquisite artistry. Attention to background composition and light evoke a sense of intimacy and a touch of nostalgia, especially those images that were printed in sepia tone. One of the difficult tasks was to select a limited number of representative images for which there was clear contextual information. After making the final selection, I organized them into different categories—landscapes, historical monuments captured during reconnaissance trips, local people, archaeological excavations, and aerial surveys.

Schmidt was an important witness to Iran's social evolution in 1930s. Some of the images render a portrait of Iran on the threshold of social and economic change. The newly adopted hat, as seen on some men wearing

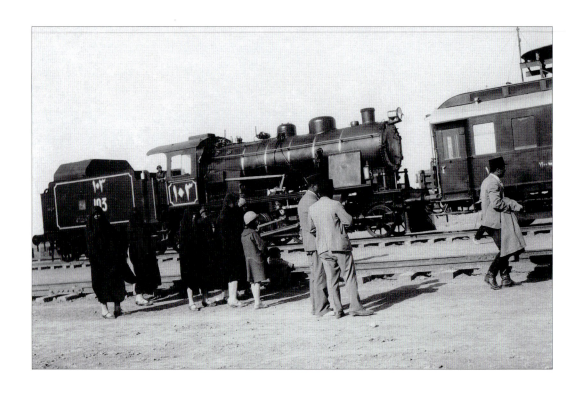

Figure 52. Railroad engine and engineers, a hallmark of modernity, the railroad was built jointly by American and German engineering firms. Note the traditional "chador" worn by women. March 1932. Neg.#83411.

them, was known as the "pahlavi külah," in the shape of a pillbox, that had replaced the tribal hats. Western–style military uniforms became the fashion, and travel by train was a symbol of modernity [Figs. 50,51,52].

These images display a thick slice of life in Iranian social history. In focussing on common people, nomads and farmers in their local environments, the photographers offer a glimpse of peoples' daily activities [Figs. 53,54,55]. Some of the images capture people in moments of privacy: a man reading his Koran [Fig.56], an old woman peacefully smoking her waterpipe in a teahouse [Fig.57], children at play in a courtyard [Fig.58]. There is an intimate shot of a young woman reclining on her bed with her opium pipe next to her tea glass [Fig.59]. Except for a shy village girl who appears to be caught by a stranger's camera [Fig.60] people in general do not seem concerned about posing for a photograph [Fig.61]. An unveiled woman grins at the camera while baking bread in front of her house [Fig.62]. Other categories of images, some of

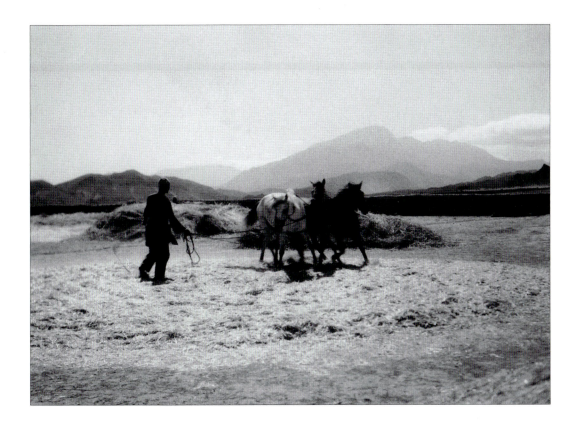

which we have already seen, are dramatic landscapes with or without monuments and various types of excavated objects. There are contemporary village complexes of intricate mudbrick architecture, closeup images of life at excavation sites, of visiting dignitaries, Persian, European and American, some friends and colleagues. An accompanying cd-rom includes dozens more such images.

Schmidt's photographs reveal a discriminating eye and obsession for travel through the rugged Iranian landscape. The image of the heavily loaded Ford appears as a metaphor for the tribulations of his archaeological journeys [Fig.63]. In certain ways these travels remind one of Freya Stark's legendary voyages in the Near East in the late 1920s and 1930s. A contemporary of Schmidt, Stark was a keen observer and a prolific writer who crisscrossed the impassable valleys in Iraq and Iran, riding her mule accompanied by a local guide.

Figure 53. Threshing field, near Damghan, with a horse-drawn threshing board which had cutting edge flints inserted underneath it. The horses circled for hours to separate the wheat from the straw. July 1932. Neg.#83992.

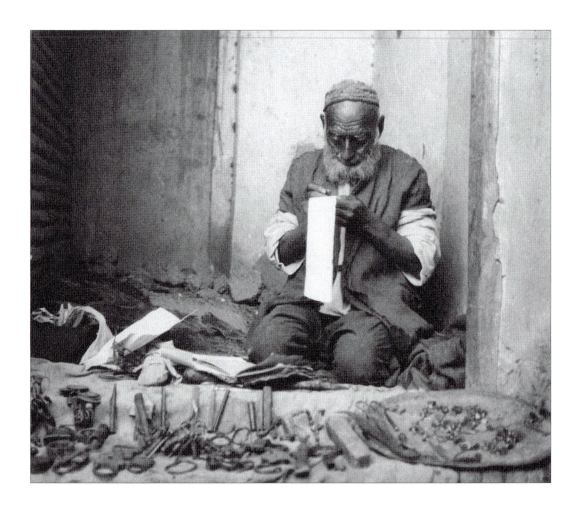

Figure 54. A shopkeeper selling scissors in the Damghan bazaar. May 1932. Neg.#83971.

Schmidt's archival photographs open a window upon the Iranians of the past century, their history, and culture. At the same time, the correspondence and other archival documents offer a rich resource for understanding a history of archaeological work in the region on which our present and future research stands.

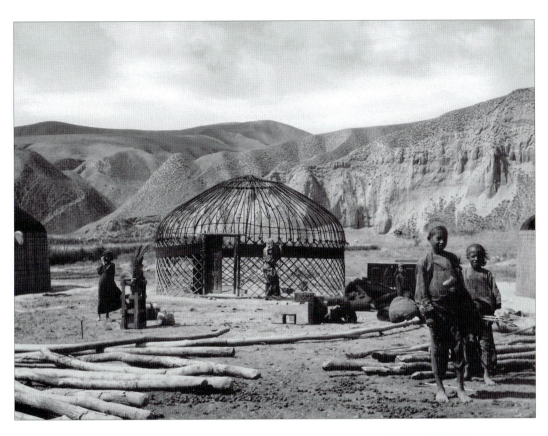

Figure 55. Turkoman nomads building a yurt, near the Iran-Turkmenistan border. September 1932.

Figure 56. A man reading the Koran in his room, wearing his "külah." July 1932. Neg.#83367.

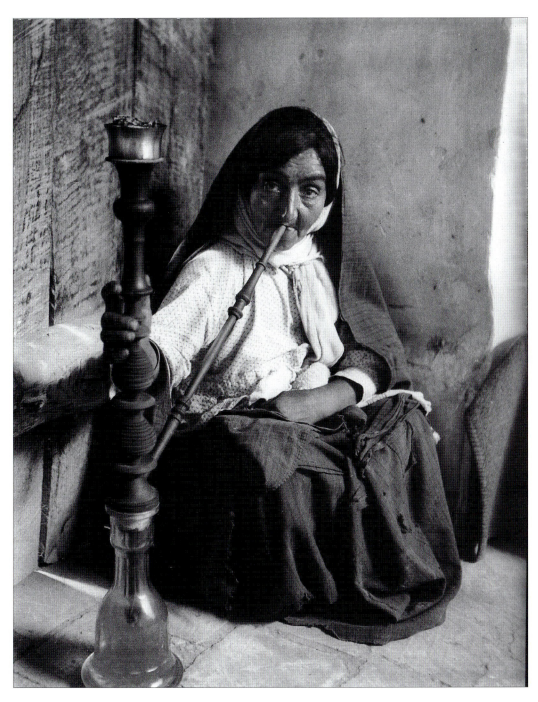

Figure 57. A woman water-pipe smoker "Kaliunchi" ('nargilah' in Arabic and Turkish) in a teahouse. July 1932. Neg.#83371.

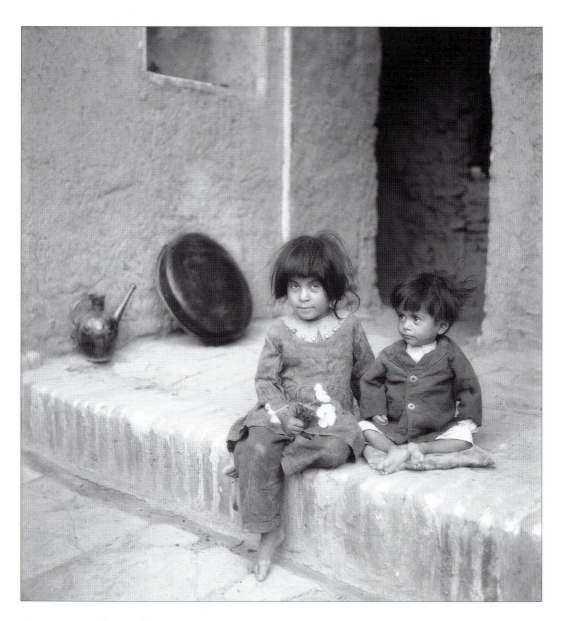

Figure 58. Brother and sister at play in front of their mudbrick house. July 1932. Neg.#83365.

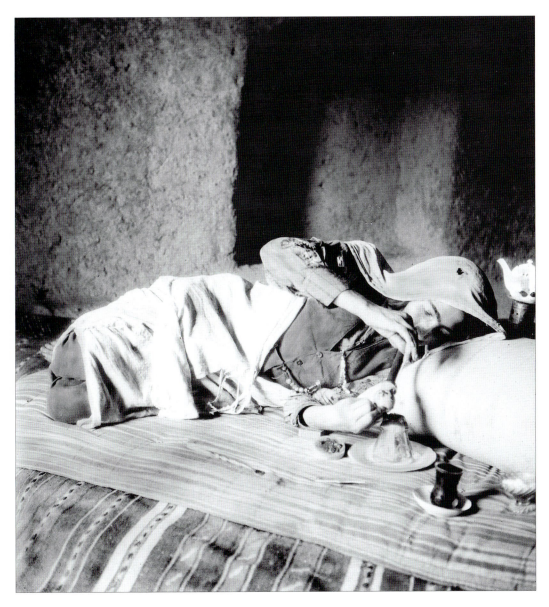

Figure 59. A woman smoking "shire" (a potent byproduct of opium) which is smoked in lying position. In the 1930s women of ill-repute would frequent the opium houses in urban areas and some large rural centers, and such a woman could be photographed (pers. comm. A. Alizadeh). Note her tea glass to the right, on edge of the bed. July 1932. Neg.#83372.

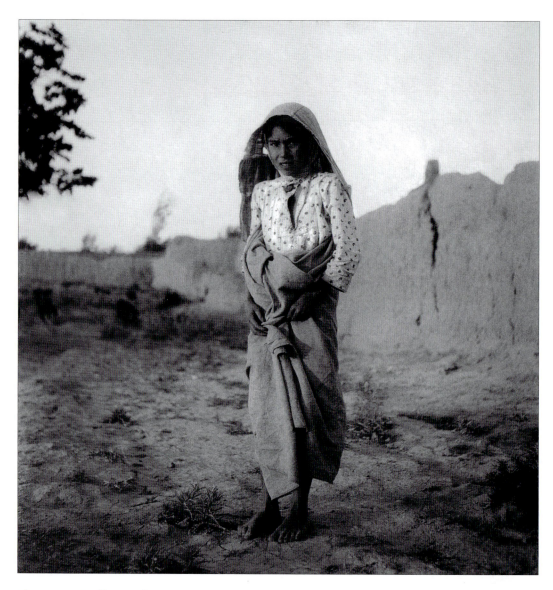

Figure 60. A village girl
near Damghan. September
1932. Neg.#83970.

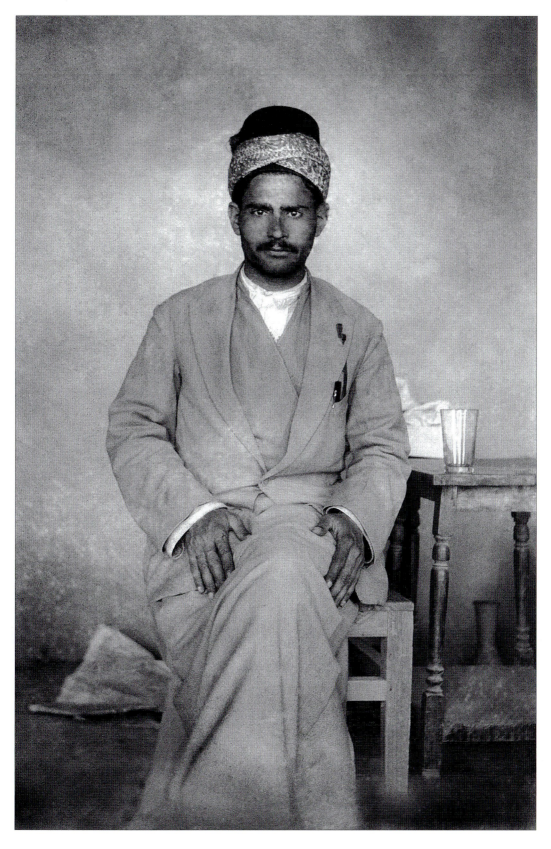

Figure 61. An Arab man in a coffeehouse, Diwaniyah Iraq. February 1931.

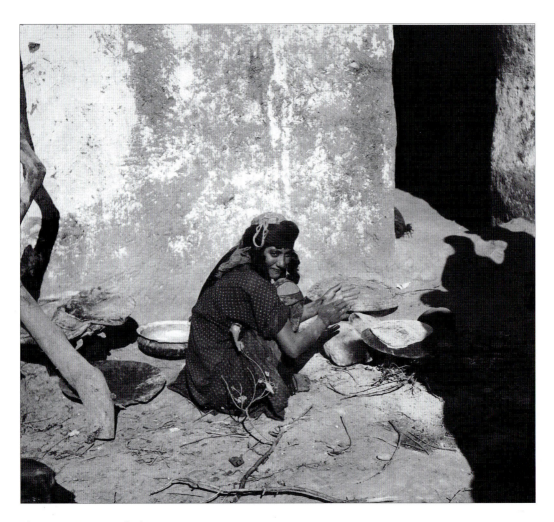

Figure 62. Woman baking flat bread on "saj" (metal plate) over a hearth in her courtyard, village of Qaleh, Muruni, Luristan. The "saj" is still popular throughout the rural regions of the Middle East. March 1932.

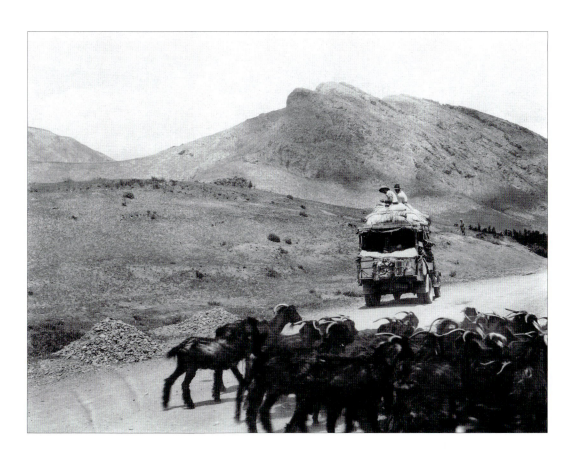

Figure 63. On the way to Hamadan during a reconnaissance trip; to the left is a small tell. June 1931. Neg.#82574.

References

Correspondence between Horace Jayne and Erich F. Schmidt, 1930–39: Box #s 1, 2, 33–34, 40. General correspondence box # 2, papers 35–38. Archives of the University of Pennsylvania Museum of Archaeology and Anthropology, Philadelphia, PA.

Dyson, Robert H., Jr., and Susan Howard, eds. 1989. *Tappeh Hissar. Reports of the Restudy Project, 1976.* Florence: Casa Editrice Le Lettere.

Editors of Time-Life Books 1995. *Persians: Masters of Empire.* Alexandria, VA: Time-Life Books.

Haines, Richard C. 1965. "Erich F. Schmidt Memorial Issue Part One." *Journal of Near Eastern Studies* 14, 3 (July): 145–47.

Hohmann, John W., and Linda B. Kelley, eds. 1988. "Erich F. Schmidt's Investigations of Salado Sites in Central Arizona." *Bulletin Series* 56. Flagstaff, AZ: Museum of Northern Arizona Press.

Kimball, Fiske 1937. "The Sasanian Palace at Tepe Hissar." *Excavations at Tepe Hissar Damghan.* Philadelphia, PA: University Museum/University of Pennsylvania Press. 347–50.

Madeira, Percy C., Jr. 1964. "1929 to 1941: "Stout Deeds on a Lean Budget." *Men in Search of Man: The First Seventy-Five Years of the University of Museum of the University of Pennsylvania.* Philadelphia, PA: University of Pennsylvania Museum of Archaeology and Anthropology.

Majd, Mohammad G. 2003. *The Great American Plunder of Persia's Antiquities 1925–1941.* Lanham, MD: University Press of America.

Martin, Harriet 1972. "An Archaeological Study of a Third Millennium City, Its Internal Development and External Relations." Ph. D dissertation. Oriental Institute of the University of Chicago.

National Cyclopaedia of American Biography 1969: 671–72. New York: J. T. White.

New York Times 1931. "Cemetery of 2000 BC Unearthed in Persia; Pennsylvanians Find 'Unknown' Race's Relics." November 2.

Pezzati, Alessandro 2002. *Adventures in Photography*. Philadelphia, PA: University of Pennsylvania Museum of Archaeology and Anthropology.

Pope, Arthur U. 1932a. "Splendid New Examples of Sasanian Art: Sculptural Ornament from a Recently Found Palace at Damghan." *Illustrated London News* (March 26): 482-84.

————1932b. "Find Persian Dancer Buried in Splendor: Palatial Home Discovered." *New York Times* (September 12).

————1933. "Relics of Prehistoric Art in Northern Persia." *Illustrated London News*. (January 28):116–19.

Schmidt, Erich F. 1932. "From Iraq to Persia: An Archaeological Interlude." *Art and Archaeology, the Arts Throughout the Ages.* 33, 2:59–70.

————1933. "Tepe Hissar Excavations 1931." *The Museum Journal* 23,4.

————1937. *Excavations at Tepe Hissar Damghan*. Philadelphia, PA: University Museum/University of Pennsylvania Press.

————1939. "The Treasury of Persepolis and Other Discoveries in the Homeland of the Achaemenians." *Oriental Institute Communications* 21. Chicago, IL: Oriental Institute of the University of Chicago.

————1931–40. Photographic Albums 1–16: Philadelphia, PA: Archives of the University of Pennsylvania Museum of Archaeology and Anthropology.

————1940. *Flights Over the Ancient Cities of Iran*. Chicago, IL: Oriental Institute of the University of Chicago.

Schmidt, Erich F., Maurits van Loon, and Hans H. Curvers 1989. *The Holmes Expeditions to Luristan*. Chicago, IL: Oriental Institute of the University of Chicago.

Stark, Freya 1934. "A Journey to the Valley of the Assassins." *The Valleys of the Assassins*. London: John Murray.

White, Erskine L., Jr. 1982. *An Archaeological Journey to Persia*. Ardmore, PA: Privately printed.

Index